Kosher Meat

Kosher Meat

edited by
Lawrence Schimel

SHERMAN
SA SHER
Publishing

Acknowledgments:
The editor gratefully acknowledges the publications in which some of these stories, often in different versions, first appeared. The specific acknowledgments appear on page 6.

Book Design: Judith Rafaela
Cover Design: Janice St. Marie
Cover Image: Judith Rafaela, Janice St. Marie, invisible horse design, Aquino International, Kenneth Mastro, and Aryeh Swisa
First edition, printed in USA

Library of Congress Cataloging-in-Publication Data

Kosher meat / Lawrence Schimel— 1st ed.
 p. cm.
 ISBN 1-890932-15-9 (softcover)
 1. Gay men--North America—Biography. 2. Gay men—North America—Fiction. 3. Jewish gays--North America--Biography. 4. Jewish gays--North America—Fiction. 5. Homosexuality—Religious aspects—Judaism. 6. Homosexuality—Religious aspects--Judaism--Fiction. I. Schimel, Lawrence.

HQ75.7 K67 2000
305.38'9664'0922-dc21 00-032997

Sherman Asher Publishing
PO Box 2853
Santa Fe, NM 87504
Changing the World One Book at a Time™

For Achy Obejas

ACKNOWLEDGMENTS

Many people have helped, in various ways, to make this anthology a reality. I am grateful to Judith Rafaela and Nancy Fay for their enthusiasm and support for this project. I should also like to thank, in particular, for their advice, suggestions, and friendship, the following people: Tony Kushner, Keith Kahla, Michael Bronski, Michael Lassell, Michael Barnett, Leo Skir, Sandi Dubowski, Wayne Hoffman, David Tuller, Abraham Katzman, D. Travers Scott, Matthew Rettenmund, Neil Roland, Teresa Theophano, and Cecilia Tan. And, most of all, my thanks go to all the authors for their wonderful texts; it's been a long journey, and I'm glad you all hung in there with me.

Contents

Building an Appetite: An Introduction

Lawrence Schimel

While it sometimes seems that nearly every Jew or homosexual fancies himself a writer, ready to pen his life story (one of these days...), there has been relatively little written about our gay Jewish lives (or at least, little that has been published), neither within the specialized presses nor from the mainstream publishers. This creates a feeling of invisibility within either the gay or Jewish communities—a lost tribe, fallen through the cracks of the system. Especially when a glance through bookstore shelves makes it seem like every other possible permutation of hyphenated minority identities are already represented with volumes of their own. (Yet both Jews and homosexuals have a reputation as strong book-buying communities—reputations that I sincerely hope will prove to be true insofar as the sales of the present volume!)

We gay Jews might not often choose the traditional fashion to multiply our numbers (though we are, one could say, fruitful) but we do exist, and do often manage to find ourselves, as evidenced by the many queer congregations all over the globe. It was my hope to arrange a literary meeting of this widely scattered, sometimes-hidden tribe, to help us affix our position more firmly on the literary map similar to the way that the foundation of the State of Israel helped to place Jewish concerns on the world agenda of nation-state politics.

Besides, I couldn't resist the title. And as should be evident from the above paragraphs if nothing else, I'm a sucker for wordplay.

It's been a long-ish journey, this anthology you hold in your hands. Twice it's been sold to gay presses, with much initial enthusiasm, only to have the project canceled for various reasons. But fortunately, the contributors stuck with me through the handful of years while this book was in limbo, and eventually a small literary press in

Santa Fe, Sherman Asher Publishing, recognizing the need this volume fills, had the courage to bring it to light, even though it deviated so drastically from anything they had hitherto published.

Kosher Meat gathers a minyan of authors writing both intimate memoir and fictional stories, which explore this ill-defined borderland where these two seemingly disparate realms—being gay and being Jewish—meet and overlap, sometimes with the clash of open conflict and sometimes with a welcome embrace.

The essence of this collection is the desire of Jewish men for other men. While sexuality is a natural and important part of our human lives, it is also one of the areas most troublesome for the reconciling of religion with lifestyle.

One could say that the writers in this volume aren't afraid of a little trouble. In fact, they go looking for it, wrestling with angels and demons both, and not afraid to admit they enjoy the tussle. From the catharsis of sex as a way of coping with images of the Holocaust to pieces about father/son (and Daddy/boy) relationships and expectations, these writers don't shy away from publicly avowing desires or ideas that run counter to traditions so long-standing they've become de facto norms. And tradition itself becomes a fertile playground for one author, who reworks the Jewish myth of the golem in a tender love story.

The gay Jewish playwright Tony Kushner wrote in his essay "Fick Oder Kaputt!":

> It is impossible to talk or write about sex without
> revealing too much of yourself. Whereas conversely
> it is possible I think to *have* sex and reveal nothing
> of yourself whatsoever.

While certain physical attributes—the absence of foreskin, say, or stereotypical Semitic features—might be manifest indicators of Jewishness during sexual encounters, a Jewish identity is certainly something that can be concealed, or simply set aside, during conjugal congress. And so many Jews seem to do exactly that, living as if these two aspects of their lives, their sexuality and their Jewishness, were separate personalities—something akin to Dr. Jekyll and Mr. Hyde, perhaps. As we live in a sex-negative society, you can guess which identity would play the role of the monster in the above metaphor.

Part of the confusion stems from the difficulty of figuring out what it means to be Jewish in a secular setting. Because to be a Jew can imply so many different things—a culture, a tradition—apart from the act of praying to a single God in a Jewish (as opposed to other) fashion.

Kushner's statement can be modified slightly, substituting Jewishness for sexuality. It is quite possible to be a Jew and reveal nothing of yourself whatsoever. But to talk or write about being Jewish... now one must open a vein and confront feelings the writer might not even be aware of himself.

The writers in *Kosher Meat* lay bare their souls to reveal their innermost thoughts, desires, passions, and anxieties about both sex and Jewish identity. These revealing tales of love and lust—often poignant, but with a good dash of both chutzpah and camp—will enlighten, delight, arouse, and inspire the reader, while pushing the limits of previously conceived notions as to the intersections of sexuality and religion.

It is my hope that for those gay Jewish readers who've been feeling like the aforementioned lost tribe, wandering in a desert-like wasteland and wondering why their own lives and dilemmas are not reflected in the literature, this volume will seem like manna sprung suddenly from the sands, nourishing the soul as much as it feeds the body.

I hope that non-gay and non-Jewish readers will gain an insight into the lives of their lovers, friends, and family. Maybe even finding themselves turned on by the passion of the men in these tales. For through the sharing of pleasure one will find compassion.

Sex, like life, is often a spicy dish. It is my hope that, even for a vegetarian such as myself, this portion of *Kosher Meat* will prove to be fare that satisfies the appetite.

Ess gezunterhait!

My Nazi Summer

Jonathan Wald

In my defense, I met him in the dark, so I didn't know until later that he was a Nazi. All I knew was that he was tall, and muscular, and that he liked how my body felt. He didn't actually say he liked my body; if he had I would have heard the accent, and it would all have been over. I could just tell, from the way his hands moved over my chest, the way he was breathing, sharp and deep, the way he kissed me more than he kissed the other guy feeling us up in the dark. That third guy was only there to make me and the Nazi feel closer. It was because of him, because of the way we both excluded him, that we knew we cared about each other, the Nazi and I.

My mother hated Germans, Germans and cows. She practiced public land law, and she hated cows for ruining a vital public resource, and she hated Germans for killing Jews. Everything was black and white for my mother, good and bad. I was good, my sister was bad. Democrats were good, Republicans were bad. And Germans were definitely bad.

It's not as if she was religious, my mother. The opposite: she and my father moved away from the East Coast to get away from their crazy Jewish parents. My parents hated religion and the destruction they thought it caused in the world, the wars, the pain. Maybe they even thought, somewhere deep inside them, that the Jews caused the Holocaust. That without religion, the war would never have happened.

Growing up, I was never supposed to have German friends, or visit Germany on my trips to Europe. Once when I thought about buying a sensible Volkswagen, my mother's passion overran her

practicality, and she said no son of hers would ever own a German car. Oddly enough, the Japanese were okay. Even though they were on the wrong side of the war, they never targeted the Jews. They were along for the ride; they could be forgiven. I bought a Honda.

The Nazi wasn't wearing a shirt when I met him, and I could feel his smooth Aryan skin under my fingers and against my stubbly cheek. That was the first part of him that I had a crush on, his skin. Then on his muscles. Then on the way he kissed me. His beautiful torso was just barely outlined with silvery moonlight as he caressed me. It was my first summer on Fire Island, and I was twenty-one and a little pudgy and never in love. Nothing like this had ever happened to me before. It's lucky he didn't want to do anything unsafe, because I would have done it. Instead, we just kissed and felt each other as I held on tight. We still hadn't spoken when we came, and we didn't speak as the Nazi led me away from the third guy, who was still trying to shoot.

I was in high school the first time I ever saw pictures of people killed in concentration camps. Some of the bodies were alive, and some were dead, and there wasn't much distinction between the two. Even now I can't have sex with men who are very thin. I see their bones outlined by their skin, and even if I close my eyes, I feel the man's skeleton under his insufficient flesh and my sexual thoughts vanish like dust. I can only think of those flickering black and white movies in Mrs. Wolfsohn's social studies class, skeletons walking or worse—lying still as they were bull-dozed into mass graves.

Sometimes I think I should have been born in the nineteenth century, when people valued fat, when it was obscene to show your bones. I always thought my revulsion toward skinny men was a sign of my sympathy for my people, or at worst a result of my own fear of death. Now, as I remember that night on Fire Island, it occurs to me that my revulsion may be much worse, a sign of my own self-hatred: I'd rather sleep with a living Nazi than a dying Jew.

That summer on Fire Island someone had put a pair of legs right up against the wall of their house, right where the wall met the ground. The legs were covered in striped black and white stockings, and on their feet the legs wore beautiful ruby red slippers. As the Nazi led me through the bushes toward the moon-

lit beach, I saw the legs, and it was as if Dorothy's house had landed on the Wicked Witch moments before my lover and I passed. And so the world felt a little safer as we stepped onto the beach and I saw what he looked like for the first time. He looked like he felt. He was tall, and blond, and muscled, with a strong square chin. His body was hairless and muscled, his skin smooth and unblemished. He didn't need a uniform, or any insignia, or an extended right arm to look like a Nazi. This is what Nazis looked like naked.

When I was in fifth grade I was forced by my parents to play AYSO soccer. I was terrible at it. I wasn't fast enough or strategic enough to be a forward, so I never got the glory of scoring points. I wasn't big enough to be a fullback, and I certainly didn't have the dexterity to be a goalie. So I, who hated all forms of exercise, ended up as a halfback, running up and down the field, up and down, relentlessly. My teammates hated me because I held them back, and they excluded me from their socializing and their camraderie.

But one day star-forward Andrew, who I knew from Hebrew School, brought a *Hustler* magazine to practice. Providence allowed the coach to be late that day, and so 13 horny 11 year-olds huddled around Andrew, watching as he proudly flipped the pages. Most of the pictures were of women, and I already knew I didn't like them, but I hooted and hollered and surreptitiously adjusted my jock just like everybody else. I imagined my teammates getting horny, and that made me horny too.

But one of the spreads burned into my mind: a prison scene, with male guards and female prisoners. It was a gigantic orgy, with the guards fucking the prisoners, and the prisoners servicing the guards, and it was pretty sexy. My attention went to a cop in the corner, sitting on a chair, his pants around his ankles. His cap was pulled down over his eyes, seemingly asleep in the midst of the orgy, but his dick was still hard and straight up in the air. He was like me, separate from the others but still aroused. Perhaps he was even dreaming of being in a much more satisfying orgy, surrounded by hunky male prisoners who he could punish or reward at his discretion. Suddenly the coach arrived, and we tore up the magazine and stuffed the pages into the bushes, as macho Andrew wailed that it belonged to his brother, who was going to kill him. Ever since then, nothing turns me on like a man in authority.

I had never been with a man like the Nazi; I had certainly never been chosen by a man like him, picked from among the countless men of all sizes and shapes wandering through the bushes that night. I was the chosen person, chosen by a beautiful man to make love in the moonlight, chosen to the exclusion of everyone else. I thought I would live with him forever, if not in Manhattan, then maybe in the bushes on Fire Island. My feelings for him were unshakable. By the time the Nazi spoke, his German accent powerful and unmistakable, no prayer, no act of God, could have convinced me to walk away. I was in love with the Master Race.

My mother used to call things by their wrong names. We would be sitting at the dinner table, meatloaf congealing on the serving plate, and she would say, "Put the milk back in the oven," when she really meant the refrigerator. Sometimes she would call things by no name at all. I would be clearing the table, and she would ask me to "put the thingamabob in the whatchamacallit," meaning put the dishes in the dishwasher. Even when I understood what she meant, I would stubbornly pretend not to. Her lack of clarity embarrassed me.

So when I say that the man I met on Fire Island was a Nazi, what I really mean is that he looked like a Nazi. And sounded like a Nazi. If the man in the bushes had really been a Nazi I like to hope I wouldn't have slept with him. I like to hope his muscles wouldn't have been enough. I certainly like to hope I wouldn't have gone to his beach house the following night.

The Nazi had invited me over, given me the address as we lay on the beach, making out, getting sand into our socks and under-wear. I imagined that it was the first step in our eventual moving in together, and as I made my way home over the creaking board-walks, I repeated the address again and again in my head, terrified of forgetting.

I was distracted the whole next day as I thought about my Nazi. My housemates noticed my distraction, and also noticed my bloodshot eyes and my guilty demeanor. They battered me with questions until I gave in and blushingly told them about my Nazi trick. They were all Jews, my housemates, gay Jews from New York City, but they weren't really religious. I was the religious one; I was the one who went to services regularly, who at eight years old had convinced my atheist parents to send me to Hebrew School

because I already felt guilty about being gay. So my housemates wanted to hear only about muscles and skin and hair and jawlines. They had no doubts, as they went through their day, researching cocktail parties, wheedling invitations, and changing outfits, that I should go to the Nazi's house that night. They were older than me, and wiser, and less prone to crushes than I was, less bewitched by the ocean air. Encouraged by them, I halted my fretful weighing of my responsibilities to my people versus my insatiable libido. I let my libido win.

As I made my way toward the Nazi's beachhouse, I passed Dorothy's twister-tossed shack. This time the ruby slippers were gone, removed by the Good Witch's magic, given to Dorothy so she could find her way home. As I wound my way along the thin wooden boardwalk, I imagined that I too was going home. I drove myself forward, imagining what it would be like to have sex with the Nazi tonight, how good it would feel, not having to worry about getting sand in my genitals. When I finally found his house, I stood outside for a long moment, debating. Then I went inside.

I could never have imagined what I would find. My Nazi lived with two housemates, who were in the midst of preparing dinner. I don't remember one of them at all, bland as he was and unremarkable. But the other one was small and dark, with curly black hair and a big Jewish nose, handsome and intelligent. I was appalled. I thought about what my mother would have said if I had wanted to live with a Nazi, even for a summer. It was against the laws of nature. I half expected the Holocaust to be reenacted before my eyes.

Instead, they served me salmon mousse shaped like a salmon. The Jew had made the food—he was a caterer back in Manhattan—and he and I did most of the talking. He was bright, passionate, and opinionated. I sat across from him at the dinner table, my Nazi next to me. I could feel the Nazi's muscular thigh pressing against mine as I stared at the Jew, full of desire and shame.

No one ever believes my parents are from New York. They don't look Jewish; they don't sound Jewish. They weren't religious, and they didn't spend much time with Jews, except on Passover, which we attended out of a sense of social duty. I had grown up a continent and a generation away from New York Jews, kept separate from them by design.

And yet, everyone has always believed I was a New York Jew. Some people have assumed I was from the East Coast just because I was Jewish. I had a New York accent long before I lived in New York, and I possessed Jewish cultural and social behaviors which must have come to me through recessive genes, passed from my grandparents through my goyish parents, only to resurface in California, in me.

So the connection I felt with the Nazi's Jewish housemate was immediate and deep. My infatuation with the Nazi was immediately revealed to be flimsy and muscle-based, the desire of a hostage for his captors. My real love was for the Jew, for my own people. All through dinner, we ate and we argued, the Jew and I. My Nazi stayed quiet but strong. Under the table, his hand moved up and down my inner thigh. And as the night went on, I became more and more aroused by the Nazi's hand and the Jew's mind. By the end of the meal my crush on the Jew was overpowering. But dinner ended, and the Jew and the forgettable roommate prepared to go dancing. The Nazi asked if I wanted to go, although he clearly didn't. His idea was for us to stay at the beachhouse, alone. I was torn, and went to the bathroom to think it through.

I was standing at the toilet unzipping my pants when the Jew entered the room. I froze. He noticed.

"Is it okay if I get ready in here?" he asked.

"Sure," I lied. I tried to be nonchalant as I turned my back to him.

"I take it you two aren't going to come dancing." I couldn't tell if he was flirting with me. I wanted him to be flirting with me. He unzipped his pants. I held my breath. He casually tucked in his shirt, his hands moving down into his crotch and back.

I tried to urinate, but I couldn't. "It sounds like fun," I said wistfully. "But the Nazi doesn't want to go." I didn't call him the Nazi. But I thought it. I thought we could bond over that, two Jews in the bathroom, kept apart by the cruel wishes of the Master Race.

"Another time," he said, zipping up his pants and preparing to leave the room. I still hadn't been able to urinate, and I felt like a fool standing statue-like in front of the toilet, my hands on my dick. My chances with the Jew were about to disappear. I couldn't stand it.

"You could stay here with us," I whispered to his back.

Now we both froze. The first time I'd had a three-way was almost by accident the night before, with the Nazi and the interloper in the bushes. Then, the interloper had gotten in the way. I thought tonight I could have it all, the Jew's mind and the Nazi's body. I thought nobody needed to be excluded.

There was a pause, but not for very long. The Jew looked over his shoulder, but he didn't turn around. "Thanks anyway," he said. "Maybe we'll see you at the club." He opened and shut the door quickly. I remained at the toilet, unable to stop trembling.

I came out of the bathroom as quickly as I could, scared that the Jew might have a chance to tell the Nazi what had happened. I sat awkwardly as the Jew prepared to leave, but the Nazi seemed oblivious to any tension. And after the other two had gone, the Nazi gave me the best blow-job I've ever had. He didn't want any reciprocation. I just lay back while he serviced me. He complimented me, telling me how good I tasted and felt. I thought about the Jew, dancing, and about what it would have been like if he'd stayed. Maybe the Nazi would have serviced both of us Jews. I felt guilty for my infidelity, and maybe that added to the thrill. I came, we exchanged Manhattan phone numbers, and I left.

I walked home, ashamed and elated, disappointed and afraid. At the turn to my house, I noticed that the Wicked Witch's stockinged legs had shriveled up without her shoes. Dorothy was off to see the Wizard, who hopefully would grant her wish and send her home.

I ran into the Nazi and the Jew at a dance the next day and neither one would talk to me. I'm sure the Jew told the Nazi what happened in the bathroom. And now they both felt betrayed. The Jew must have thought it was his duty as a loving friend to tell the Nazi that I was dangerous and not to be trusted. Allegiances had shifted, and for a man who looked like the Nazi, loyalty was more important than lust.

I in turn felt betrayed by the Jew. He had ratted on me, given away my secrets, sent me off and out of their lives. Couldn't he see our connection, that ran deeper than his friendship with the Nazi, that ran through our blood and our history? It was divide-and-conquer, the oldest trick in the book!

The Nazi would have been good for a week or two. But the Jew and I could have fallen in love. I wondered why he hadn't seen that.

The next week I was back in the bushes by the Fire Island beach. As I watched the mating dance, the rejections and acceptances, the beckoning touch and the pushing away, I began to understand. And I asked myself a different question: What had made me think my own kind would not betray me? I thought of our history as Jews, put upon, enslaved, hated by the dominant culture. Always in exile. And I came to realize that's the way it always is with love and war and the history of the Jews: somebody has to be excluded. Exclusion is sexy. I left the bushes alone, and as I made my way back to my beachhouse, I noticed that the legs were gone from Dorothy's house: the witch was dead, the illusion over, and Dorothy was back to reality.

My People

Michael Lassell

For Andrew Mellen

A desire for knowledge for its own sake,
a love of justice that borders on fanaticism,
and a striving for personal independence—
these are the aspects of the Jewish people's tradition
that allow me to regard my belonging
to it as a gift of great fortune.—Albert Einstein

I'm floating on crushed pillows in my room at the old hotel. My heart is slowing, finding its normal rhythm with confidence. I am completely... satisfied, sated. I can hear the shower running in the bathroom ten feet away, while I lie here, eyes closed, thinking too much, as usual, thoughts that shouldn't be thought. Not in the moments after... after sex... after making love to a beautiful stranger who is somehow part of me. I am thinking that I ought to be staying in the moment, and I am—I am letting the moment buoy me—but my mind keeps flashing futures. And histories.

My mind is a warehouse. Here is a dusty parcel: "He was one of those people whom pleasure reassured afterwards, rather than saddened, and who found in it a renewed taste for life." I don't know where the words come from. I mean, I'm sure I knew once, but it's lost, like so much I knew once. All I remember are these words that are part of me, that *are* me. I am staying in the moment, letting the "afterwards" of the pleasure reassure me.

Shower. He is in the shower. David. His given name, not the name he goes by, but the one I prefer, and he hasn't told me not to use it. He is naked now. He has been for hours. Wet and naked and showering in the odd diagonal tub beyond the small dressing room on the other side of the television armoire.

How long has it been since I first heard that the Jews of Hitler's concentration camps were lured into tiled halls with the promise of a shower only to be gassed to death as they stood there waiting to be cleansed, a religious obligation as well as a human need? Their guard down, their expectations high, they look up to the ceiling nozzles only to be extinguished with caustic cyanide gas or crushed in the collective panic of a thousand lives simultaneously refusing to be exterminated.

How long since I first head that? Thirty years? Forty? And have I ever taken a shower in all that time without thinking that the shower head of my childhood home or high-school gym or hotel room in Europe or Asia would let loose a hemorrhaging dose of acrid gas? Have I ever heard the word "Jew" or "Nazi" without thinking of showers?

"Why so many pillows?" he asked when I opened the door and showed him the room: bed, wet bar, armoire.

"When my lover left me," I replied, "I couldn't sleep. Then I saw George Burns on TV saying that he couldn't sleep after Gracie Allen died until he slept in her bed. So I started sleeping with Seth's pillows, *hugging* his pillows. It was the only way I could get to sleep after having had someone in bed with me for so long. I still can't sleep without at least four of them. Six is even better."

I feel the heat coming off his skin as we stand there staring at the lazy street below, the curtains draping us like... a bunting? a shroud?

He was standing on the fourth-floor bridge watching two women, one middle-aged, the other—heavier, taller—in her late twenties (a mother and daughter I guessed—no stranger is exempt from the instant scenarios my mind spins instead of being still). I had, of course, noticed him earlier, going through the metal detector, checking his backpack, waiting for the elevator.

"This isn't all of the names," the older woman was saying, almost annoyed as she scanned the hundreds of exotic, evocative words etched in the thick and doubtlessly bullet-proof glass that

prevented us all from leaping to our deaths on the concrete floor below.

"This is not *all* the names," she continued, somewhat confused, lost even.

"These are not *people*," he said with authority (but without a hint of judgment). "These are the names of whole towns and villages that were wiped out."

That was the first thing I heard him say.

No. He said thank you to the woman who took his backpack at the checkroom.

"Oh...," the woman said, so suddenly stricken that her hand fluttered up to her breastbone. Her sternum. *Stern...* The German word for star.

Her daughter, a doughy, uncared-for woman with long stringy hair, looked at her mother, her slack jaw reminding me of the dead women in the films behind us, back a few galleries.

Then he turned to face me over his shoulder and winked with shared experience, common knowledge.

The women walked off, clutching their belongings around them for protection, the way the Jewish women of Europe had as they boarded trucks and trains, as they stood on lines, until—naked—they had nothing to clasp against their breasts except their own vulnerability and their deep shame and their dread. Jewish women, Polish women, gypsies...

"My name is Sariel," he said, extending his hand.

"Michael," I said.

"Ah," he said, "the archangel who expelled Satan from Paradise..."

"Who stands guard at the gates to prevent man from returning to Eden," I chimed in, "and who stopped Abraham from sacrificing Isaac on Mount Moriah."

"From the Hebrew..." he went on, as if prompting an answer.

"For 'who is like God,'" I finished, always the best little boy in the class. "And the most common male name in the country."

"Well, it's beautiful. That's why it's... popular."

"Well," I said, trying to soften the hard edge I know my voice carries, "if there were as many godlike people in America as there are Michaels, it'd be a much nicer place to live."

He was small, well, smallish—shorter than me, thinner. His

skin was parchment white. He had longish dark hair that was more limp than luxurious, though it had a slight wave to it. He had a scraggly red beard and luminous black eyes fringed with inch-long lashes.

"Ariel, is it?" I asked, having not quite heard his name.

"No," he said laughing, his full red lips tinted with blue. "Sariel. It's an anagram for Israel."

"Ah," I said. "Your parents were religious."

"Not really. I mean, they're very Jewish, just not religious. They're obsessed with the Holocaust, in their way. My mother is totally into it. My father is in very deep... denial, or something, but we were never religious. I don't think they ever go to *shul* any more. Yom Kippur maybe. I made Sariel up when I was a kid. My real name is David."

"The giant-killer," I said with a broad smile.

"The *beloved*," he replied focusing the laser power of his eyes at mine.

"Well," I said, "you may not believe this, but Michael is my middle name. My given name is *Jonathan*. I use Michael because my father's name is Jonathan, too."

As his mouth opened into a larger smile, his eyes seemed to squint, disappearing into his glee. He could have been twenty, I remember thinking, or forty. His hands were immaculate, his face seemed like something out of an old painting, one in which candlelit faces float in a general darkness.

From behind us a group of school kids pushed noisily onto the bridge and clattered across it without even noticing the names of the murdered towns as they went about their tour.

When I turned back from the distraction, David was leaning on the handrail, appraising me. "I saw you," he said, "back at the liberation videos. You were weeping."

"Well—don't you find them unspeakably sad?"

"Yes, of course," he said. "But they're videos of the *liberation* of the camps. There's some joy in that, too, surely."

I turned and looked through the glass with the meticulously etched names of the missing towns of Latvia and Lithuania, of Romania and the Ukraine, my mind fixed on the phrase, "as often as you do this, in remembrance of me."

"They're complex emotions," I said as he moved to look out

and down with me, a constant file of museum-goers moving behind us, most of them speaking in the hushed tones one uses in cemeteries and art galleries. And wasn't this place some part of both?

"I was thinking about the dead," I told him. "I was... mesmerized by those newsreels of the good citizens of Buchenwald, forced by the Allies to tour the camp, to see the dead, the people they had murdered by their silence, their inaction. I was just... well, *mesmerized* is the only word for it, by the women with their hands over their eyes, over their mouths. They looked just like my mother from photographs in the Forties. I was wondering if it was horror they were feeling or nausea or just embarrassment that the great Aryan race had lost the war. But I felt sorry for them, too, God knows why. My constant identification with the defeated, I guess."

"You're not Jewish, are you?" he asked, turning toward me.

"I was brought up Christian, but my father's mother was Jewish.."

"So your father was Jewish..."

"But it was my grandmother's *father* who was Jewish, not her mother. So she wasn't really Jewish, either, I guess, not by Old Testament law, not according to the Nürnberg definitions, either, as I understand them."

"And your mother?"

"German Lutheran."

"Oh," he said, seeing the significance in the facts. "Mind if I join you?" he asked, "I mean, if you're going to go all the way through."

"I don't mind at all," I said.

But I wasn't really sure I wanted his company, or any company at all. I didn't know if I wanted a first conversation, the revelation of life's details, the possible rise of desire, or the usual rejection.

"I've been here before," I told him. "I really only came back because there's something from Einstein I wanted to write down."

"I've been here before, too," he said, seeming to mean more than what he was saying. And then he smiled as innocent as new-fallen snow.

He was 28. His father's parents had been killed in Bergen-Belsen, but he hadn't actually known them very well. He'd been

sent to England with an older cousin. After the war the two children, no longer quite so young, went to live with relatives in New York.

"For my father," Sariel said, "it was, I think, as if his parents had never existed. His being a Jew somehow died with them, not his being Jewish, but his being a Jew—there's a difference. Not because he felt ashamed that they had died, but because it was so... I don't know. Remote?"

He looked up at me for confirmation. I had no idea what to do, so I shrugged something halfway between, "Whatever you think" and "Yeah, probably."

"My mother's parents managed to get out, first to Buenos Aires, then Havana, then New Jersey. My parents met in 1961, in the Catskills. They got married the weekend after Kennedy was killed. I have an older sister who has two children."

"That's it in a nutshell, is it?" I asked.

"Well, you know... what else? I grew up in Chicago and went to school there. I work at the Library of Congress. I'm a Pisces, but I don't eat fish. I play violin. I live near Dupont Circle, but other than that, I don't have much to do with 'gay life' here. It's way to preppy for me."

"Not a regular at J.R.'s, eh?" I joked. The place was populated exclusively by wannabe lovers of closeted bureaucrats and the bureaucrats' assistants.

"The boys from the Hill are way too Republican for me. The lefties are way too boho. There's something about tattoos that I just can't separate from the camps."

"The plight of the bourgeois artiste," I said. "Being inextricably bound to a class that is strangling you. Wanting out, but afraid to go."

"Well, it's no joke," he said, but we both laughed.

"I know," I told him. "I'm a writer—by default, because I really have always wanted to be an actor, and I'm actually employed as an editor. I'm an artist *manqué,* and I'm totally fed up with gay men."

"The beefy boys?"

"Exactly. I walk down the streets of New York, and I watch all the muscle puppies ogling each other and ignoring anyone who isn't perfect, and I think that 'body fascism' is *exactly* the right term.

If you aren't perfect, you are death-camp fodder. I mean, I get that it's the abuse we've suffered that makes us so peculiar, but I feel as alienated from gay men these days as I ever did from straight men. Of course, my therapist is constantly telling me that not *all* gay men are assholes, but the assholes are the visible ones, aren't they? I mean, these gym jerks are running around and keeping people out of their ball games the same way the straight boys did at school, where I was a fat sissy kid who liked art."

"So you're... bitter?"

"Oh, I don't know. On the way to bitterness, maybe."

"But you're not angry enough to strap yourself into leather, either?"

"You think leather is about anger," I laughed. "I am *so* sure that is not politically correct. And I totally agree with you." Something about him made me feel on the verge of a smile the whole time in a way that seemed as authentic as depression.

"Well," I said, "I have been told that the only way for a gay man over forty to have sex is to patronize the S&M clubs, but I keep thinking that leather is just the black shiny version of a KKK sheet. I don't want sex to be about pain or humiliation or even power, although I'd be lying if I said I never had power fantasies about sex."

"Tell me," he said, cocking his head to one side, half quizzical, half flirtatious.

He was making it easy to be honest. "Well, most of my sex fantasies are cinematic. Not just visually, but I mean, inspired by movies. I have Marquis de Sade fantasies... from *The 120 Days of Sodom*—Pasolini's film."

"I never saw it."

"He set it in Fascist Italy, which was brilliant, but it made me totally sick to my stomach. I still can't get the idea out of my mind of being in total control of a pack of strapping adolescents. Of course I wouldn't make them eat glass and dog shit, and I certainly wouldn't cut their dicks off. I'd probably wind up having vanilla sex with them and falling in love with one of them and wanting to open a flower shop. Another fantasy I have is me as the Nazi commander, thanks to Visconti's *The Damned*. But the objects of my lust are never Jews. It's the Aryan boys I'm after in these fantasies."

"Very kinky," he said. He seemed to be in on some secret he

was just about to reveal.

"I strip ranks and ranks of them naked," I said, feeling the heat rise up in my ears—partly out of embarrassment, "and I walk up and down picking the most perfect of them. I run my hands over them. I caress their buttocks. I fiddle their genitals with the end of my riding crop until they're erect. I choose the best of the best. I make them have sex with each other against their will. I push myself inside them... dick, tongue, fingers. I fuck these straight boys until they love it. I hang them by the wrists and starve them until they're begging to be buggered. This all comes from my having grown up feeling absolutely powerless, I'm sure."

His eyes were unbelievably kind. But not necessarily accepting. "There are men in Israel," he said, his voice quite even, "who actually act out concentration camp fantasies—at least in their pornography—where they are the Nazis and the women they force into sex are Jewish concentration camp victims."

"God," I said. "There just is no accounting for the way life experience sinks into the libido, is there?"

"Absolutely none," he said, and smiled even more broadly.

A silence settled between us while we just looked at each other, wondering if we were going to let it seem awkward.

"This is not the kind of conversation I usually have when I first meet someone," I finally said.

"No," he said. "It's fine. I grew up totally in charge. Of my mother's happiness, of my father's.... well, happiness will do for him, too, if ignorance is bliss. I was responsible for my own Jewish education, since he couldn't have cared less. I had to help my older sister in school. All she ever cared about was boys. I had my violin lessons, which seemed terribly important to everyone else so I almost forgot how much I love music, how intensely pleasurable it is to be able to play. Of course, I was in love all the time—men, boys. The boys in the orchestra at school. I was so in love with the boy who played first cello. He was so tall, so... white. I mean, Chicago is full of Scandinavians and Poles, and this boy could have been on a Nazi Youth poster."

"Tomorrow belongs to him, eh?"

"My sex fantasies are all about total passivity," he said, "of being taken, not exactly forced to have sex, but controlled. And in my fantasies, I just let go of everything, and I just let older, larger

men pick me up like a doll, like a pet they love to stroke, and somehow by letting them do whatever they want, by completely suspending my will, I become myself? Does that make sense?"

It didn't.

"Isn't passivity what made the Final Solution possible?" I said.

"Maybe. I'm not sure. The same thing happens when I'm playing. There's a point of... transcendence? Where I'm completely *servicing* the music, where I'm at the *mercy* of the music. It does whatever it wants to me, and I have no control of it. And that's when I am most me, most the musician me. That's what I play for. That moment. It's overwhelming to me. It's like God to me."

And I could see tears filling up his eyes.

"Actually," he said, "the Final Solution was made possible by indifference, by apathy and evil. Not by *surrender*, not how I mean it."

"I love these," he said as we entered the tower containing hundreds of elegant portrait photographs of the people of Eishishok.

I read the legend on the exhibit for the first time. The Nazis shot and killed every man, woman, and child in Eishishok on September 25 and 26 of 1941, the night before Rosh Hoshana, and buried the whole town in mass graves, extinguishing a Jewish legacy that had been part of the area's history for nine-hundred years.

"The weekend of my parent's first anniversary," I said, re-marking on the date. "The day they were married, the Kosciuszko Bridge in Greenpoint, in Brooklyn—where they lived—was being dedicated. My Uncle Jack almost killed himself speeding to the wedding because he couldn't go over the bridge and had to go around. Kosciuszko was Polish, but served in the American Revolution. My Uncle Jack's wife was Polish, too, and my godmother. My sweet Aunt Helen."

"Was she Jewish?"

"No. Catholic. My mother's parents hated her enough just because she was Polish. And a *flapper.* Most disreputable—and far too fun-loving for my German grandfather, who managed to die from ulcers. If she had been Jewish, the marriage would never have happened. She died when I was eighteen. There's a scene in some old black-and-white movie, and everyone is at the 1939 World's

Fair in New York. And suddenly the lights go out in the Polish Pavilion—because Hitler has just marched into Poland. And they turn on a radio, and the radio voice says, 'The lights have gone out all over Poland.' I keep thinking about that scene, and my Aunt Helen. My light went out when she died. My parents were dating in those days, my German Lutheran mother and my half-Jewish Anglo-American father. I have pictures of them at the World's Fair. But, when you're my age," I said, though it wasn't the first time I'd said it, "a lot of the people you've known are dead."

"When you're my age," he said, "the same is pretty much true. Between AIDS and the Holocaust," he said, "I'm dragging around a lot of dead people."

We walked past the piles of shoes and the piles of glasses and avoided the freight car because of my claustrophobia. As usual, there were crowds around the exhibit of the "medical" experiments.

"I think this stuff is awfully raw for young kids," I said, pointing out some eight-and ten-year-olds perched on tiptoe to see what was going on behind walls not quite high enough to protect them.

"I often wonder how I'm going to handle it when I have kids," he said. "I don't want to kill their innocence, but I don't want to shield them from the truth, either."

"So, David," I said, "you're going to have children?"

"Oh, yes. Absolutely. Someday," he said. "Somehow."

"Such a responsibility," I said.

"Such a joy," he said. "Such amazing potential. Such fun!"

We took our seats in the small theater and watched filmed images of men and women who looked well-fed, well-groomed, well-cared-for. They were survivors, and their suffering was right under the surface. One woman was talking about a forced death march, another about crawling over bodies to survive. A man had hidden a Czech boy in a pig sty to keep him alive. Another man told the story of Hanukkah in the death camp: the Nazis hung Jewish prisoners upside down on the fences, then set them on fire, one a day, as candles for a human menorah. The people in the theater, who looked like people at any mall, were all weeping, the way people in any mall would be weeping if they weren't filling their lives with shopping instead of thinking. I wasn't sure it was a

bad choice.

I had my arm on the back of the bench, around David's shoulders. He, too, was crying.

"The thing about the Holocaust Museum," I remember saying to a friend after my first visit, "is that no matter who you arrive with, you wind up alone, just you and the truth of it."

But I wasn't feeling so entirely alone this time.

"Let's go," he said, long before we'd seen all the footage.

I didn't say no.

We sat under the cherry trees, our legs dangling off the Tidal Basin wall over the water, watching the tourists stream in and out of the Jefferson Memorial across the water.

"Washington is always so crowded this time of year," he said.

"For the Cherry Blossom Festival?" I half asked.

"Yes. All those kids on their school trips from all over the country. All those happy families."

"Is your family very unhappy?"

"Oh, not actively. I mean, they didn't kick me out when I told them I was gay or anything. We speak. My sister doesn't forbid me to see her children. My parents think of her divorce as a mixed blessing, since he's Italian."

"Not a Finzi-Contini I'm guessing," I said.

"More like a would-be Corleone."

I made a sound that was supposed to be chuckle, but came out more like a snort.

"It's just that, when I see these happy blond families all I can think of is that if this was the Thirties, they'd be Nazis and I'd be wearing a yellow star. Something about the holidays makes it worse."

"Tomorrow is Easter," I said.

"And Passover."

"I like it when they coincide," I said.

"Why?"

"I guess I feel... resolved?"

"The two halves of you?"

"It's not really halves. I never even knew my grandmother was Jewish. She died just after I was born. Of cancer. All I know about her I make up from photographs. She had a look of such extraordinary longing and sadness about her... like that Dust Bowl

woman in the photograph from the Depression."

"The Jewish look," David said.

"I don't think I have the look," I said, "but I have the feelings. The longing... the Wandering Jew thing. I was tortured for *not* being Jewish in my high school, which was almost entirely Jewish."

"In New York?"

"Outside. Great Neck."

"Oh," he said and shifted closer on the stones. That's when I felt the warmth of him for the first time. It was unseasonably cool and cloudy for this time of year in D.C.

"I have a distant cousin who lives in Bethesda," I said. "She's the great-granddaughter of my grandfather's oldest sister. And she works somewhere in official Washington and her boss is Jewish."

"She's not?"

"No, she's from the very waspy old-American side of the family, my father's father's side. Anyway, she's talking with her boss one day about the Holocaust, and he tells her that his mother was a survivor of Dachau. That she was liberated by the American forces. And she tells him that her father—who is my father's cousin Ralph, I think—was *in* the American unit that liberated Dachau. Which is zero degrees of separation or something."

"If my mother lost any people over there, they were too distant for her to have known them. My father can't *stand* hearing about the Holocaust. He has *no* interest in coming to the Memorial. All he ever wanted to do was assimilate and forget his parents and what happened to them and the people who let it happen. He thinks being Jewish is a weakness. He thinks something could have been done to stop Hitler, that *he* could have done something, and he was, I don't know, ten years old or something."

For the first time, his face got dark. He stared into the water and even seemed to shudder, to shiver.

"Would you like my jacket?" I asked.

"Um... if you're not cold."

"No," I said, "my body temperature runs a few points higher than normal."

"Isn't that a line from *Body Heat?*" he said, suddenly smiling again. "What are you, Kathleen Turner? Are you trying to seduce me?"

"I thought you were trying to seduce me," I said. "You winked first."

"Well, you looked first," he said, and I had. I felt terribly guilty, of course, *cruising* the Holocaust Memorial. I was sure he had loathed me for it.

"Looking is what museums are for," I said and helped him arrange my jacket over his shoulder. Our legs were nearly touching. Then he slipped his right arm into the crook of my left.

We sat there staring into the water while the Peorians and Birminghamians in their pastel polyesters trekked past us admiring the cherry blossoms above our heads. Petals were falling like a light snow. My head was working overtime, of course.

"Does your mind never stop?" a woman once asked me.

"No," I told her, shocked to realize that other people *do* have minds that stop, occasionally, or that don't race all the time. Their tapes don't play while they're sleeping, their dreams do not haunt them with images, their minds are not workaholic enemies of the bodies they inhabit.

"The first time I saw the pictures... the liberation films," I said, deciding to tell him, "I was in junior high. I was probably the only kid in the class who wasn't Jewish. The only one who wasn't sobbing, practically, since some of my classmates knew they might very well have been looking at the bodies of their own grandparents. You know what I was looking at?"

"The genitals?" David asked.

"Yes," I said, shocked. "How did you know?"

"It was the first time I'd ever seen a dick other than my own," he said.

"Me, too," I said, "and they seemed so huge. That's another thing I was thinking about when I was looking at them again. I was wondering if my sexuality is somehow tied up in these piles of dead men whose cocks are the only thing about them that seem alive, those normal-looking sex organs attached to those emaciated dead bodies."

"Well, the survivors talk about the will to live... the life force... It's the once thing they all seem to have in common. That no matter what new horror life threw at them, they were able to do whatever they had to do to survive."

"But the price they paid..."

"There is always a price to pay for life," he said. "There is a sense that all of us do things to survive—or things we think we need to do to survive—that we're not proud of, that damage us. That doesn't make us inhuman. It's the way life is."

"Well," I said, as the cold water slip-slapped at the wall just below our feet, "I'm not so crazy about what life has thrown gay people either."

"No, it can be bad."

"I keep thinking that when the Allied forces liberated the camps and found out that some of the prisoners there were gay, they kept them in prison. *That* little piece of information had a profound effect on me, on my bitterness, if that's what it is. I guess it's no wonder I always feel like I'm in prison."

"Imagine how the Jews must have felt," he reminded me, "who managed to get passage on a ship out of Europe, when no port in the world would allow them to disembark, but sent them back to die in Germany."

We sat with our backs to the Washington Monument, looking out across the Reflecting Pool to the Lincoln Memorial in the distance. Around us, a bus load of Muslim women were standing, chatting, pointing, giggling.

"That's where the World War II Memorial is going to be built," he said, pointing to the Rainbow Pool.

"I'm not a big fan of any of the new memorials," I said. "I don't even go to funerals anymore unless they're for good friends. The Holocaust Museum is the only place I've felt anything like a catharsis. Although it's not really healing, is it?"

"I don't know. Chemotherapy is awful, but it can be healing. It's hard to *feel* healed when you're focused on death and torture."

"The thing that drives me crazy is the guilt, the survivor guilt."

"About the Holocaust?"

"No. AIDS. But it's the same thing. You know Ruth Prawer Jhabvala, the woman who writes all those Merchant Ivory movies...?"

"The Indian woman?"

"No! She's a German Jew of Polish extraction. She married an Indian and lived in Delhi for twenty-five years, but she's European."

"You're kidding."

"Her family left Germany in 1938, I think it was, at the last possible moment, in any case, but all their relatives stayed behind. When the war was over, it turned out that every single one of them had been killed. And her father was so distraught that he killed himself."

"You feel like that?"

"Yes. I do sometimes feel like that. I mean, sometimes it seems that most of the people I loved all died way too young. My friend Kenny... he was so full of life. I felt really alive when he was around. He got so frail and sick before he died... He never lost his light, though. I keep thinking of him like that, too weak to get in or out of a bathtub, his body like a skeleton. Like one of the camp dead."

"You don't you take any strength from survival? No joy?"

I looked into his polished obsidian eyes. They wanted me to say yes. But they were the kind of eyes that also wanted the truth.

"No," I said. "I haven't felt any joy since 1987. That was the year Kenny died and my friend Clark, and my lover left me for another man. I would give anything to experience joy."

He looked into my eyes, then looked at the crowd, the scene, the setting sun.

"This is the first man I ever loved," I told him, and drew my fingers over Ralph's name, etched into the polished black granite. "He died in 1968, while I was living in London."

"I wasn't born in 1968," David said.

"That is *not* an endearing remark in any circumstances," I told him.

"Was he your lover?" he said, re-changing the subject.

"No, he was straight. But I loved him, and he knew I was gay. He was the first straight person I ever told. We grew up together. He was everything I wanted to be—beautiful, popular, athletic. I was in love with the concave hollows at the top of his thighs."

"You saw him naked?"

"We were on a basketball team together as kids, adolescents, whatever. He was a fighter pilot. Missing in action presumed dead. My parents didn't tell me until months later, when I got home."

"That was considerate."

"My parents," I said, "are petrified of emotion. My mother

won't talk to me unless I'm in a good mood. I was never allowed to express emotion as a child, and I'm not allowed to express it now. If my mother had been in Germany during the war, she would have been a Nazi."

"Ouch."

"Oh, she wouldn't have been an *active* Nazi. She would have been one of the ones who didn't want to know. Who would have said, 'We have to do what Hitler says, because he is the chancellor.' She would have been one of the women at Buchenwald covering her eyes and mouth and pretending that she had never smelled the odor of burning flesh in the night, that she didn't know the ash falling on her picturesque little town was the ash of Jewish bodies, that those were not the screams of slaughtered pigs she heard while she ironed her husband's S.S. uniforms, the screams of starving mothers watching their children skewered on bayonets. She's not an evil woman; she's the casual kind of anti-Semite, and she's a racist, too, of course. I have guilt about that, too, that I have this black-hating, Jew-hating, fag-hating blood in my veins. And that I still love her instead of killing her."

"You have Jewish blood, too."

"Yes," I said, "I do. I wish I knew more about it."

"Do you always go for younger men?" he asks as we stand on the interminable escalator up from the Metro at Dupont Circle.

"I want to say no," I answer, while a stampede of platinum-haired cheerleaders run up around us screaming. They make me want to cup David's genitals in my hand.

"Why?"

"Because I think 'no' is the right answer."

"There is no right answer."

"My first two lovers were both four years younger than me. I was twenty-five when I met my first, a feisty little Chicano from San Francisco. He's dead now. My second, the one I haven't let go of yet, he's still alive, but he lives in L.A. I keep getting older, but my taste in men doesn't. I find myself looking for someone with the understanding of a fifty-year-old but at half the age. Men my own age all seem to act like old men—not *wise* old men, just tired, uninterested, finished—or desperate, running around circuit parties pumped up on ecstasy."

"Men my age seem like children," he says.

"My therapist says that pursuing younger men is one of the ways I make certain I stay alone."

"There are younger men who prefer older men," he says as we near the top.

"No there aren't," I say. "There are only younger men who think they prefer older men because older men have money or the kind of self-assurance the younger ones think they don't have themselves. I'm nobody's 'daddy,' emotionally speaking. I'm still just finding out about myself."

"Well, that's probably why you think of younger men as peers," he says, and slips his hand into mine.

"This isn't done in Washington," I say.

"I know," he says.

"So," I say, opening the door to 416, "do you have a boy-friend?"

"Oh, what perfect timing you have," he laughs, walking past me into the room: bed, wet bar, armoire. "Of course I have a boyfriend. I'm young and good-looking, aren't I? Isn't that what you're thinking, that you are alone because you're old and unat-tractive and that everyone who is young and good-looking is blissfully happy?"

"Yes, I do," I say. "I do think that."

"My first lover was twenty years older than me," he says, standing in the middle of the room, his hands at his side.

"He had a heart attack in Grant Park on his way to the Art Institute. Dropped dead at forty-two."

"I'm sorry," is all I can say, but my mind is racing with where he was coming from, where he was going, on what path, what bridge? What was the exhibit at the museum when he died?

"My second lover," he goes on, "the sweetest man who ever lived, was my age, or closer to it. He was already HIV-positive when we met, but I thought we might have ten years. We had fourteen months. His family barred me from the hospital. He was Catholic."

"I'm sorry," was all I could say.

"My last lover," he continues, "was run down and killed by a hit-and-run driver about a hundred yards from here about a year and a half ago."

"Jesus," I mumble, an old habit leftover from worse days.

"Really?"

He stops talking now. And I do, too. I stand there watching him watch me. His head declines slightly, and he looks shy as well as sad.

"No. I'm exaggerating," he says. "I'm trying to make a point."

He is looking like David at the feet of the felled Goliath, somehow embarrassed by what he has done.

"If you don't love life every day," this small boy in a young man's body says, "then the Nazis win. The homophobes win."

I wait until my mind is finished with its objections, then I walk over to him and try to put my arms around him.

"Don't," he says.

"I'm sorry," I say. "I just thought..."

"I don't mean I don't want you to touch me," he says. "I just don't want you to do it for the wrong reasons."

"What about compassion?"

"With *passion*," he says, "with affection, in the present—and no dead bodies in the bed with us."

And I take his face in my hands and stare into his enormous eyes as he wraps his arms around me and pushes his hips into my hips.

"Cherry blossoms," I say, and I kiss him.

And he kisses back.

For hours.

ISAAC AND MOSHE

Rick Stanford

The two little boys were sitting on the steps of a walkway across the street. All dressed up in black suits, with little black beanies on the back of their heads, they didn't seem to have anywhere to go or anything to do. They had been wandering up and down the street for a while, but now they were still, and their attention was settling on the person directly across from them: me.

I was reading.

I'd brought my canvas-backed director's chair out of the house and was sitting in it facing the sun. It was the last Saturday before the end of the year and the weather was beautiful: all I had on was a pair of gold-colored trunks. My feet were propped up on one of two low brick walls that bordered the walkway leading to the courtyard apartments where I lived, and on it I had arranged my dictionary, my binoculars and a cup of coffee.

But I was finding it difficult to concentrate. I had moved into my apartment thirteen years ago, the Jewish school across the street had opened shortly thereafter, and in all that time I had never really engaged any of the boys who went there in conversation. I guessed the two boys across the street from me to be about fourteen. They were Semitic looking and the taller of the two was rather attractive.

I knew how to begin the conversation. I had imagined it in my mind a hundred times, and now as I looked down at my book, and back over at them, I wondered if this were the moment. What the hell.

I looked at them directly.

We were definitely looking at one another.

Okay: "Do you believe in God?"

They both immediately stood up. Not only were they being

addressed by an adult, they were being asked the most basic question about the only thing that really mattered.

"Yes—Of course, don't you?"

"Of course not," I answered, matching their self-assurance. "I think life is meaningless," and I had to catch myself before I added, "and stupid." If life was stupid, it couldn't also be meaningless.

"Then how did all this come to be?" one of them asked. That sounded like a trick question.

I answered cautiously, "I don't know."

"You don't know," the shorter of the two boys said, very satisfied, "But I know."

"How do you know?"

"It says in the *Torah*."

"That's just a story."

"It's God's revelation."

"Men wrote that book—not God."

Stalemate.

In the silence a car passed between us. When it had gone by there was a sudden interjection from up the street. "The Jews killed the son of God."

I turned around in my chair, and saw a fat man in a torn T-shirt leaning against a car, his arms folded over his belly, with a smile on his face.

"That's stupid," I said, and turned back to my book. I was baiting the boys, but not like that. His was a conversation I definitely didn't want to take part in, and I was willing to sacrifice my talk with the kids to avoid it.

I don't know what happened to the fat man, but as I sat there trying to read I became aware of the two boys approaching me. They weren't just walking toward me across the street, however; they had split up and were coming at me from two different directions. One of them was angling down the street and then back up to me, while the other was making his way from behind: they were reconnoitering a target.

When they had at last regrouped they were standing just beside me. My chair, however, was on an embankment several feet above the sidewalk so, from my perspective, they were slightly below me and looking up. I acknowledged them with a nod of my head: Yes?

The smaller of the two boys began the offensive: "If there is no God, then how did all this happen?" and he made a gesture indicating the street, and meaning the world: the apartment houses, the palm trees, the parked cars and the sky.

I gave a different answer this time: "Arbitrary accident."

Both boys scoffed at this.

"Do you think this is a perfect world?" I asked them.

"Do you think this is the only way things can be or ought to be? I think that shows a lack of imagination."

"Then how did you get here?"

"I don't know."

"You don't know." The smaller boy, in particular, was contemptuous.

"But I have the courage to admit that I don't know. You have to be very courageous to believe in nothing," I told him.

The little boy came right back at me: "You have to be very courageous to believe in something."

I was willing to concede that point, "That's true. Sometimes." But I wanted to get back to the question of this inevitable, perfect and created world. "What about the Holocaust? Do you think God wanted that to happen?"

This was obviously a tricky point for them. They weren't agreed on how to answer me. The taller of the two boys, the better looking, the more thoughtful, let his friend answer. "God wanted those people with him," the little boy said.

"And so he made them suffer?"

"Maybe they did something bad."

I looked at him in disbelief.

He hurried to offer an explanation. "Let's say a man is good, but he isn't circumcised, then he will have to come back in his next life to get circumcised."

I wasn't exactly sure how this related to the Holocaust and God's existence, but I'd never heard of this before. "The Jews believe in reincarnation?"

Both boys answered me at the same time. The taller boy said "No" and the smaller one said "Yes." I gave them a shrug: What gives?

They went into a conference. The taller boy answered. "Yes, the Jews believe in reincarnation, but it's a special thing. Not

everyone gets reincarnated."

"The Anointed One gets reincarnated," the smaller boy said.

"He is always with us, yes," the taller boy affirmed.

"He's alive." The little boy seemed to be emphatic about this.

"What's 'the Anointed One'?" I asked.

"That's what we call the Messiah," the taller boy explained.

"You think the Messiah is alive?"

"He is always with us. He returns with every generation. We're just waiting for him to reveal himself."

I didn't quite know what to do with this information. I had a momentary vision of a second—*first*—coming here on Alta Vista Boulevard. "Aren't you going to be mad at him when he does come for not revealing himself during World War II?"

"No," and here the taller boy seemed to be making a special effort to clarify an important point, "You see, the Jews weren't ready then. Before the Messiah comes we have to be prepared and ready as a nation."

This was really shocking to me: the regulation of collective self-hatred. Well, for now, for the moment, I would offer myself as another possibility, a window on the outside world, and—maybe even—a salvation.

"Do you believe in Moses?" I asked.

"He saved our people," the smaller boy said.

"That's the story. That's what it says. But except for the Bible there is no other historical evidence for his existence."

"His name is Moses," the taller boy said, indicating his friend.

I looked at the little boy with his rounded, almost chubby, face. "Your name is Moses?"

"Moshe," he said .

I turned to the taller boy. "What's yours?"

"Isaac."

"My name's Rick."

We looked at one another: we all had names.

"I just wanted to make the point," I said, "that all recorded history is within the last five thousand years or so, and in the scheme of things that's nothing. I just read a couple of weeks ago that they discovered a genetic link that indicates that every single person on this planet is descended from a woman who lived in western Africa one hundred and fifty thousand years ago. Can you

imagine how long ago that is? The Torah was written, at the most, three thousand years ago. I mean, there's no difference between the Torah and the old Greek gods. I just finished reading *The Iliad* and they thought the gods all lived on this mountain in Greece—"

"That's just a story, " Moshe asserted .

"I think what you believe is just a story," I said.

We looked at one another and once again we seemed to be at a stalemate.

"Have you read Leviticus?" I asked.

"We've memorized the Torah in Hebrew."

"You're kidding! " I was horrified. "Really? The first five books of the Bible?"

"It's *not* the Bible," Moshe said, exasperated.

I excused myself and ran into my apartment. I grabbed my 1611 King James version of the Bible and came back outside. I opened it to Leviticus and looked up one of my marked passages. "So, if I ask you what Leviticus—chapter twenty, verse thirteen—is, you can tell me?"

"It's not like that," Isaac said, "It isn't written that way."

"It's on scrolls," Moshe explained.

"It doesn't say this?" I asked, and proceeded to read the Leviticus passage to them:

> If a man also lie with mankind, as he lyeth
> with a woman, both of them have committed
> an abomination: they shall surely be put to
> death; their blood shall be upon them.

The boys reflected on these words.

"Do you think that's true?" I asked. "That men should be put to death for having sex with each other?"

Moshe felt there was a distinction to be made here. "Before they're married?"

Isaac tried to cover up for his friend's misunderstanding. "That isn't the real Torah," he said. "You have to read it in the original."

"Well, the reason I read the 1611 King James version is that, apart from any value the book might have in terms of its content, it's a very important book for the history of English literature and the English language. I think what it says is stupid though."

Moshe looked at the book as if it were contaminated.

"If my father found that book in the house he would throw it out so fast.

"That isn't what we've memorized anyway," said Isaac.

"It's bigger than that," Moshe asserted, still looking at the Bible suspiciously.

I separated the first five books and held them between my fingers. "You're just talking about the Torah, right?"

"It's much bigger than that," Moshe declared.

"You're talking about the *Talmud*," I suggested, "with all the commentary and explanations."

"It's not the Talmud," Moshe was a little bulldog now. "It's called the *Mishnah*,"

Isaac said. "What's that?"

"It's like the Torah, but it's not. "

"Hmm." I didn't know what they were talking about.

"Well, if you have an English translation I'd like to see it."

For a moment we remained suspended there with our unresolved thoughts, and then I asked them, "Why do you wear those things on your head?"

"It shows our respect to God," Moshe said and then, in case I didn't know, "They're called *yarmulkes*"

"Do you wear them all the time?" I asked.

They both nodded, and Isaac further explained, "It represents our humility before God."

I thought about that for a bit, contemplating the yarmulkes on the back of their heads. It looked to me like the revenge of bitter old men with bald spots, coercing young men into an eternal condolence for the ravages of time.

And then I began to wonder about their haircuts: they each had a lock of hair on either side of their faces, from the temples and down over the ears.

"Do you wear your hair that way on purpose?" I asked. They both simultaneously moved a hand to the side of their heads and said, "*Peyos*."

"What's—Peyos?"

"It's one of the commandments," Isaac explained. "We're not supposed to cut our hair."

"Why?"

"We have to remember God," Moshe said.

How weird it all was—all this effort for the sake of Nothing.

"So, what do you think is the point of life?" Isaac suddenly asked me.

"The 'point of life'? Well, I don't think there is any. Except to be happy and have fun."

"And what's that?" Isaac asked.

"Well, for me, fun is reading books and having sex."

This was true, and I said it with full awareness of its power to engage. And it really was amazing: with what other teenage boys in the United States could you use the question of God and the reading of books as a means of seduction?

"Are you married?" Isaac asked.

I winced. "Ooh: no!" And then I elaborated, "I only have sex with men."

Moshe was curious. "You have sex with men? How do you do that?"

"What do you mean, how do I do that?" I asked him rhetorically, "How do you think? I suck cock and get fucked."

Moshe was insistent. "How?"

"How? How do I get fucked? Up my ass."

Now Moshe was incredulous. "It's not possible."

"Of course it's possible. You can even go over on Melrose and rent a video and see me getting fucked by two guys at the same time."

"I don't believe you."

" I used to make porno films," I told them. "I made thirteen. Wait, I'll show you," and once more I jumped up and ran into my apartment. This time I went to my file cabinet and got out the issue of *Skinflicks* with the interview of me inside. I ran back out to the boys, and opened the magazine to a page showing two cocks pushed together with me trying to engulf them both in my mouth.

"That's from *The Gold Rush Boys*. I got fucked by both those cocks in that movie."

"That's you?" Isaac asked doubtfully.

"Well, that was what? Seven years ago."

"'It would hurt," said Moshe.

"Well, it can be a little difficult at first, but men have a prostate gland inside them, and when it's massaged—like with a

penis up inside them—it feels great."

"What's a—prostate—gland?" Isaac asked.

"It's this little organ inside your body that helps produce semen."

The boys turned the pages of the magazine.

"When I made movies my stage name was 'Ben Barker.' That was my only interview."

The boys had turned to a color picture showing my tongue reaching out toward a huge uncircumcised cock.

"I wish my cock was like that," I told them.

"Why?"

"Because it's so big, and if I wasn't circumcised my cock would probably be more sensitive and I'd have stronger erections."

"But being circumcised is better," Moshe said, "it's cleaner."

"I don't think it's worth it. Being mutilated."

Moshe looked at the picture. "He's circumcised."

"No, he's not," Isaac said.

"Isaac's right," I said. "You can't even see the head of his cock because of his foreskin—and that's *with* an erection." I pointed to a picture on the opposite page. "*He's* circumcised. Can you see the difference?" Moshe contemplated the different pictures.

"It's hard to tell in that picture," I said, indicating the circumcised penis, "but I think that's the biggest cock I've ever sucked. He was great."

The boys handed the magazine back to me. They hadn't even dared to touch the Bible.

We were all quiet for a moment. I wondered if they would dream about these pictures tonight, if they would dream about me. I mused aloud, "I love semen."

Moshe was adamant: "Why?"

"Because it tastes so good. Because—I don't know. I guess because it's the original life force."

We were all quiet again.

I had an afterthought: "It's so spectacular when it shoots out."

The boys were looking at the ground, apparently deep in thought.

"This morning," Moshe said, "there was this sticky—"

"That's a wet dream," I explained.

"I didn't have a dream."

"You don't *remember* having a dream. That's great. You're lucky."

Moshe was obstinate: "*Why* am I lucky?"

"Because your sex life is just beginning. It's been more than two decades since I've had a wet dream. You have a lifetime of ejaculations stretching away before you—"

The two boys and I looked at one another over an abyss of more than twenty years, the boys concerned with their nocturnal emissions, and myself with the specter of fading potency.

Isaac looked at his watch. "We have to go."

I smiled at them. "Have a nice day."

And as they walked away I imagined myself in their dreams, in those oh-so-wet dreams, that "sticky" splashing me: their— blissfully—anointed one.

THE DAY I WAS CAUGHT

Daniel M. Jaffe

A few minutes before my memorable encounter with The Leviticus Passage, I was standing with everyone else in the synagogue's sanctuary, was watching as two men opened the wooden ark and removed one of the Torah scrolls. How beautiful and holy it looked, wrapped as it was in its navy blue velvet cover embroidered with golden leaves and vines, wearing a silver crown that dangled little silver bells, wearing a silver *yad*, a pointer that hung like a pendant and reflected the eternal flame suspended from the synagogue's ceiling. This was God's Law. "Blessed be He," we all chanted in Hebrew, "who in His holiness hath given the Torah unto Israel." The *yad* and crown and cover were removed, the velvet sash binding the two rolls of the scroll together was untied, the Torah was laid out on the wooden podium. Then we were all permitted to sit.

The cantor began reciting the hand-calligraphed words from the opened scroll while another man kept place for him using the *yad*, which literally means hand; the Torah's text was too holy for human fingers to touch. I sat in my aisle seat beside Dad, hunched over my *makhzor*, my high holiday prayer book, and read the prohibitions against seeing one's father's nakedness, one's mother's, one's sister's, and the nakedness of one's other kinswomen. Well of course you shouldn't see those things, I thought. I continued reading. Suddenly, as the handwriting on the wall had gleamed its prophecy of doom before King Belshazzar's eyes, so The Leviticus Passage gleamed before mine: "Thou shalt not lie with mankind as with womankind; it is abomination." I blinked, then shut my eyes tight.

I know, as I now think back, that I must have stumbled onto The Leviticus Passage before that particular Yom Kippur afternoon because, even if this were one of those Torah sections the teachers

had skipped over in Hebrew school, I'd been reading it in the *makhzor* on Yom Kippur every year. I always paid close attention when reading the *makhzor* because this, the Day of Atonement, was the holiest day on the Jewish calendar, the end of a ten-day period during which we repented for our sins in the hope that God would forgive us, would seal us in the Book of Life for the coming year. Maybe I understood Hebrew better at age thirteen than before and that's why The Leviticus Passage stood out then for the first time, or perhaps I was reading the biblical excerpt even more closely than in years past, or maybe, now that I'd performed my bar mitzvah ceremony and had become, in religious terms, a man responsible for his own sins, The Leviticus Passage carried greater threat. I suppose, too, that my body's maturation played more than a minor role in my increased understanding.

I opened my eyes, looked back to the text to find the terrifying lines still there. I read further: anyone who committed such abomination "shall be cut off from among their people." I shivered from a chill. I was too young to be kicked out of the house, to be relegated to the streets on my own, to a cardboard box in a gutter, at the mercy of street toughs and drug dealers. I was a good Jewish boy. No, the Leviticus Passage could not possibly have been meant for me. I flipped the page, skimmed the Book of Jonah, thought of the day's unseasonal September heat, wished I could take off my *tallit*, the prayer shawl wrapped around my shoulders, or my suit jacket or tie, felt wetness beneath my arms and at the back of my neck, felt so hungry and thirsty after nearly twenty hours of fasting, that I could imagine myself having walked all forty years in the desert. Only then, only after I'd placed some distance between myself and God's horrific words, did I glance up at Dad to see whether he'd somehow noticed my sudden understanding of The Leviticus Passage, whether he'd realized it held special meaning for me.

Dad noticed everything. Like the time, a month earlier, when he'd caught me masturbating. I was lying in bed, on top of the blue comforter, my red shirt lifted to expose my belly, my jeans and briefs shoved down to my ankles, and a facial tissue laid carefully over my pubic hair (I was nothing if not neat and prepared). Recently my body had begun to change in amazing ways: hair poked through in strange places like pioneer sprigs of grass in

Israel's Negev; voice octaves performed untrained somersaults; comet-thoughts of desire zoomed in, seemingly from nowhere, burning life into previously desolate spots. Concentrating as I was, in bed with my eyes closed, picturing myself kissing one of my teachers, Rabbi Birnbaum, and hugging another one, Rabbi Kaufman, I didn't hear Dad enter my room and approach the side of my bed until he said, in a matter-of-fact voice sounding directly above me, "It's time for supper." I rolled quickly away from him, onto my side and then my stomach, wondered first whether he'd seen what he'd obviously seen, then wondered if he'd seen the pictures of my fantasy.

"Be right down," I mumbled, not looking up at what I knew must be a narrow face gaunt with disappointment and shock.

"Your door wasn't fully closed," he mumbled as he left the room. I knew our household rule of privacy—any room could be entered without prior knocking as long as the room's door had not been clicked closed. Dad left and clicked my bedroom door closed behind him.

How stupid I'd been, not to close my bedroom door, not to click it closed. Mom, who prided herself on her voracious appetite for books, was forever saying that, according to Freud, there were no unintentionally disclosed secrets, that the subconscious mind always wanted our naughtiness to reach the exposure of daylight. "That's why you dropped string beans on the floor while stuffing them into your napkin at dinner," she explained. "Your subconscious wanted me to know you weren't eating them." Or, "That's why you tracked mud into the front hall; your subconscious wanted me to know you'd played touch football before coming home directly from school as you were supposed to. Your subconscious always tells me." She would grin broadly at that, as I would imagine Rebecca having done after she and Jacob had tricked blind Isaac.

I'd left my door unclicked; my subconscious had obviously caused me to do so on purpose; I must have wanted Dad to walk in on me, to find me. But why? As my face burned with shame against my pillow, I wondered why I would invite such discovery.

"Danny!" Dad called from downstairs. "I told you, supper!"

Quickly I finished imagining myself between the two curly haired young rabbis (no matter what, I had to finish what I'd

started), wiped myself with the tissue, zipped up, threw the tissue in the toilet and flushed. I took a deep breath and slunk slowly down the stairs to the kitchen, every step a march to the mud pits of ancient Egypt. How would Dad flay me?

Dad and Mom were sitting opposite one another at the round table, torn slices of rye bread in hand. Dad was chewing a bite, so I knew that he'd already said the *motzi*, the blessing over the bread, that the meal had officially begun without me.

Mom turned her plump face toward me. "Your father said you were in the middle of something so we should start without you."

"Uh, yeah. Thanks, Dad."

"You're welcome," he said in a voice full of meaning. So, he hadn't told Mom. Was I going to get off easy?

"Did you wash your hands?" asked Dad.

I turned crimson and nodded. Here it comes.

"Wash them again," he said. "And this time say the *bruchah* when you do."

I slipped my blue yarmulke from pocket to head, dutifully went to the kitchen sink, washed, recited the blessing about God having commanded us to wash our hands.

Seated between my parents at the table, I said my own *motzi* and began to eat. As I swallowed my first bite, Dad addressed me. "Danny—"

"Good brisket, Mom," I said, hoping to shift the conversation away from me.

"Thank you, dear. Same as always." She brought a hand to the back of her black curls and fluffed them, as though I'd just complimented her appearance.

"Danny," Dad said again, "Your mother and—"

"Something about the way you do the onions," I said to Mom as though not having heard Dad at all.

"How nice of you to notice. I—"

"Hey!" said Dad. "I'm talking!"

"No, *I'm* talking," said Mom. "Danny asked me about my brisket."

From the corner of my eye, I saw the dumbfounded expression on Dad's face. Mom knew something was up and was trying to protect me. Dad knew that Mom knew. I knew that he knew

that she knew . . . She continued, "I diced the onions very fine. Lots and lots of onions, that's the secret to a good brisket. And garlic powder. But mostly it's the onions."

"Onions," I said. "Who'd of thunk it, eh Mom?" Had she been sitting within reach, I might well have nudged her arm with my elbow or slapped her on the back or attempted some other feeble slapstick gesture of camaraderie and bonding, anything to forestall or, better still, entirely to avoid Dad's mention of what he'd just seen in my room. "So tell me, Mom, how do you peel—"

"Enough with the onions!" Dad said, slapping a palm onto the formica table top in case the cannon-like boom of his voice failed to provide sufficient emphasis. "We have something serious to discuss."

"It can wait until after dinner," Mom said and then, whispering to Dad across the table as though I weren't sitting between them, "Maybe you should talk about this with him privately."

I stopped chewing mid-mouthful, felt that I was going to be sick.

"Baloney," said Dad. "United front. United front." He turned his attention to me. "Daniel, your mother and I have been talking, and she knows that you have matured."

Mom and I both dropped our heads and stared at our plates as though in silent prayer.

"You're a bar mitzvah, after all, a Son of the Commandment, a man. So, when you have wet dreams at night—" he said this without a flinch, without the slightest catch in his throat "—you don't have to wipe up the mess with a tissue. Mom'll just change the sheets in the morning, okay?"

I nodded at my overcooked, greyish green string beans, wished that our kitchen floor were the Red Sea, that it would somehow part and swallow me up. Where was a hungry whale when you needed one?

Obviously, like Joseph's brothers lying in wait to seize him and his coat of many colors, Dad had been waiting for the right moment to inform me that, when awakening me every morning, he'd been noticing the moist, crumpled tissues beside my pillow.

Why, I asked myself, had I left the tissues beside my pillow instead of hiding them beneath it? Obviously I'd wanted Dad to find them. But why? I knew about Onan, how he'd been slain for

having spilled his seed. And why had I not clicked my bedroom door closed?

My right hand, which was resting on the edge of the table, succumbed to a nervous tic I'd recently developed—thumb and index finger began rubbing together. "Don't do that," said Dad. "When you do that, everyone knows you want to masturbate."

"*Zog nisht!*" said Mom in the Yiddish equivalent of "Don't speak!"

"Well it's true. Your Freud said so."

"I don't think you're right."

"He did, look it up."

"Whether he said so or not, it's not table talk."

They again spoke as though I weren't even there; fortunately, at the moment, oblivion suited me just fine. "Enough," Dad said to Mom. "Business is over, now we can eat hearty. So, my dear, all these years and I never knew about the onions…"

Dad did not mention the subject again. I remembered that incident as I sat in synagogue on Yom Kippur afternoon. I had been fasting for twenty hours and my stomach rumbled; Dad looked down at me, smiled at my appropriate Yom Kippur suffering. He patted my knee, and I could hear him thinking, 'Good boy.' He pointed to Mr. Goldschmidt, a former college football player, who was beginning to lift the opened Torah scroll for everyone to see. The congregation stood, chanted, "This is the Torah that Moses set before the children of Israel, at the command of God, by the hand of Moses." How strong Mr. Goldschmidt was, I thought, to be able to hold the Torah open so high, nearly over his head. Then Mr. Goldschmidt closed the scroll, set it on Mr. Heine's lap while Mr. Kagan wrapped the Torah in its velvet and silver. What an honor for these men to be allowed to care for the Torah, and on Yom Kippur no less. I envied them, but at the same time, felt unworthy. Mr. Klezmer stood at the podium now with an ordinary, printed copy of the bible, and began to read the Book of Jonah. I looked down at my *makhzor* again, re-read The Leviticus Passage, thought, while staring at the page, of Mom's hot and tender brisket, and the onions doused with garlic powder—I thought about them in part because I was ravenous, but also because they were not abominable sex, not the kind of sex that had come to

spark my masturbatory episodes twice a day.

I inhaled again through my nose, to smell the imagined food, to clear my confused head. But what I smelled was not what I'd expected: the scent of hundreds of unwashed men hanging in the sanctuary's warm, humid air. (Women, of course, had been relegated to a different part of the sanctuary since mixing men and women could lead to impure thoughts that would detract from devotional prayer.) As part of their fasting, truly observant Jews didn't shower on Yom Kippur. No washing of face or other body parts, no brushing of teeth—not a drop of water was to enter the mouth, only fingers and eyes could be washed clean. Atonement for sin was serious business. But how filth of body was supposed to lead to cleanliness of spirit, I couldn't quite fathom at the time (nor can I now); all I knew was that the scent of unwashed men suddenly was all I could smell. I inhaled through my nose, wondered whom I was smelling—the wavey-haired man in front of me with the thick, wrestler's neck? the thin man beside him whose bushy beard looked so cute? Strong Mr. Goldschmidt who'd taken his seat somewhere behind us in the crowded sanctuary?

The *makhzor* on my lap began to move—seemingly all by itself, but I knew otherwise. Abstinence from sex was as important on Yom Kippur as abstinence from food and drink; I knew that and had purposely skipped my bedtime ritual the night before and my waking ritual this morning, but now—now I couldn't help myself. When, as an adult, I recall that moment, I wonder what I possibly could have been thinking. Perhaps I was crazed from hunger, delirious from thirst. Or maybe I was a normal pubescent boy who'd missed two jerk-off sessions in a schedule otherwise adhered to with the devotion of the faithful.

I looked up furtively at Dad on my right, who was engaged in whispered conversation with the man on his other side. I looked briefly at the two decorative tablets rising high above the Torah's ark, tablets representing the Ten Commandments. I looked away, back to the men seated in front of me. I slipped my left hand to my lap, and under cover of the *makhzor*, I squeezed and rubbed, squeezed and rubbed, smelled, pictured former football player Mr. Goldschmidt, stared at the perspiration dripping down the thick wrestler's neck in front of me, stared at the side of the bushy beard in front of me, imagined licking that bushy beard, that thick,

perspiring neck until—

"What's wrong?" asked Dad.

"What's wrong?" I squeaked.

"I thought I heard you grunt something. You okay?"

"Just my stomach rumbling."

"The fast is working. You'll be inscribed in the Book of Life for sure." He patted my knee again; the *makhzor* almost fell from my lap to the floor.

I pulled out my left hand from underneath the *makhzor*, bit my knuckles until they showed blood.

"What the hell are you doing?" asked Dad, grasping my hand.

"Evil hand," I said. "It almost dropped the *makhzor*, with God's name in it. Evil evil hand."

"I think you've fasted enough."

"But—"

"Go to the hallway and take a long drink from the water fountain."

"No. This is my first all-day fast. I'm bar mitzvah now. I can do it."

Dad put his arm around my shoulders and hugged me to him. "Then behave. Make me proud."

Sitting there under Dad's embrace, feeling a cold trickle along my left thigh, I reminded myself that at least I had not done what The Leviticus Passage prohibited, that I'd only wanted to do it, had merely fantasized about doing it. But I could not escape awareness of what those fantasies had just led me to—the Onan-like spilling of my seed, of what those fantasies might lead me to in the future—the sort of depravity for which Sodom and Gomorrah had been destroyed. I looked up to the front of the sanctuary, at the Torah's ark, worried that the tablets of the Ten Commandments might fall from their place, that God might hurl them to the floor in front of the entire congregation and shatter them, as Moses hurled and shattered them after having descended from Mount Sinai, after having viewed the rabble's golden calf.

It would be years before I would find a perspective for The Leviticus Passage. It would be years before I could, like some drowning ancient clutching at the rim of Noah's ark, reach out to grab at liberal Jewish interpretations of The Leviticus Passage, to argue with myself that the Torah reflects cultural values at a mo-

ment in historic time, values that have since changed, or that maybe God destroyed Sodom and Gomorrah not for the sin of homosexuality as is generally taught, but for the sin of inhospitality to strangers, or that The Leviticus Passage was not all that important a commandment anyway—it had not made The Top Ten. I would learn to reason, too, that God created Man in His image and since I was a man, I was in God's image despite the implications of His Leviticus Passage to the contrary. The most important rationalization of all would be Dad's statement one day, made with his back turned to me after years of our having wrangled about my coming out: "No Jew can follow all the Torah's rules all the time. God knows, I don't have the will of Abraham to sacrifice my Isaac."

It would be years before I could think of these things, for neither these liberal interpretations, nor the full shape of Dad's love, were available to me as a new bar mitzvah, an alleged man who was still a mere child. These certainly were not notions available to me on that Yom Kippur afternoon as I squirmed in Dad's embrace of pride. With the clear-headedness that often follows satisfied desire, I felt horror at what I'd done. Beside Dad. Beside Dad in synagogue. Beside Dad in synagogue while a scroll of the Torah, God's Law, was out of the ark, in front of me. Beside Dad in synagogue while a scroll of the Torah, God's Law, was out of the ark, in front of me on the holiest day of the year. Beside Dad in synagogue while a scroll of the Torah, God's Law, was out of the ark, in front of me on the holiest day of the year, the day I was requesting God to grant me another year of life.

How could I be so stupid? How could I be so defiant? How could I be so wicked? I thought of my having left crumpled moist tissues beside my pillow every morning, of my having left the bedroom door unclicked closed that day while masturbating. I thought of my subconscious motives back then. I thought of my subconscious motive in synagogue now. Why had I committed such evil in a way that risked discovery? The only possible conclusion was that I wanted to be found out.

Suddenly I breathed easier, relaxed my jaw, which I had not even realized to be clenched, leaned into the underside of Dad's arm of pride. Yes, I wanted to be found out. Exactly. So I was not wicked beyond the pale of repentance-induced redemption. I

wanted to be found out. My subconscious wanted me to be found out. My subconscious was devoted to God's Law. Sitting there, enveloped in the scent of unwashed men, I took comfort in the knowledge that I wanted to be found out, that I wanted to be found out because I wanted, before I'd gone too far, to be stopped.

MEIN YIDDISHE TATE

David May

I thought that I'd done it all: Master/slave, Officer/recruit, Daddy/boy, Cop/prisoner. They were all just variations on a theme; after all, the only difference being the accouterments each of the scenarios dressed themselves up in. When I'd first discovered kink, a whole new world had opened up to me. Sex was my smorgasbord and I was determined to get a taste of everything at the table. Some scenes, of course, left me unsatisfied, even cold. I wasn't excited about military fantasies, associating them as I did with morons and Fascists, and I wondered how anyone could get hot for them. Cops were another thing, of course, provided I was dealing with the genuine article and not someone dressing-up for the part. It was the classic Master/slave relationship which garnered most of my attention, however, and I sought to fulfill my sexual fantasies in this direction with a variety of men, both Jew and gentile.

There was a formula that I came to love in each scene. I was humiliated (occasionally even in public, which was my favorite) and forced to lick my Master's boots and leathers, sometimes given an enema, then bound and blindfolded, and finally whipped. The transition from pain/pleasure to pleasure/pain came surprisingly quick for me, no doubt at least partly because my first Master, ever patient, had initiated me by slow increments into the scene I was simultaneously craving and afraid of pursuing.

When I learned to give myself up to my Master, I found I became myself, and experienced a kind of euphoria that bordered on the mystic. I felt fulfilled when this happened, riding high on the evening's finale, a long hard fuck, until he finally filled me with his cum. This kind of SM sex, of course, could last for hours. Filled with its own little rituals, it also became a process, a kind of rebirthing, that allowed me to face the world unafraid and without bullshit the next morning. I was certain that I'd found my queer

niche then, that I had found my proverbial home at last.

Then I discovered the Daddy/boy scene.

In the early 1980s, Daddy fixations were a dirty little secret. They smacked even more of patriarchy (for obvious reasons) than other kinds of kinky sex, and were (like all forms of SM) politically suspect. Even more politically dangerous was the flirtatious fulfillment of Freudian theory: If I was looking for a Father Figure, then I must be emotionally immature after all, like Freud said, and am only compounding the neurosis when I call my lover "Daddy." Or so some outsiders would have had us believe. But when a man I was dating wanted me to call him Daddy as well as Master, to control me as fathers do their sons rather than as a Master controls his slaves, I was hooked like a fish on a line by the sheer perversity of the scene. I could still be tied up, humiliated and made to service my Master's friends as before, only now I called him "Daddy" letting the epithet be savored by all who heard it.

When I found myself in another man's bed a year later, bound and naked as I watched him put on his pajamas after fucking and flogging me, I thanked him for disciplining and using me so well.

"My pleasure, boy. Daddy had fun tonight, too."

I smiled, pleased that I had pleased him.

He got into bed, spreading the covers over us as he circled me in his big, muscular arms.

"If you keep our private little games a secret," he whispered into my ear as he held me close, "you and Daddy can play them *forever.*"

I sighed deeply at these words. My cock was suddenly very hard again, but being bound I couldn't touch it. Instead I snuggled deeply into his broad, hairy chest and inhaled his scent.

"Yes, Daddy," I murmured into the darkness. "I can keep a secret."

"That's my good boy."

This, I thought, is as good as it gets. I'm home.

I obviously hadn't counted on meeting someone like David Lourea.

When we met at the Catacombs he was in full leather and I was naked. He was handsomer than any man I'd ever seen before: a *Yiddishe punim* with wavy black hair, huge brown eyes, a brilliant

smile, a thick black mustache, an olive complexion, and high Semitic cheekbones.

I wanted him bad. And I got him bad.

Perhaps, on introducing ourselves, we were both a little put off at being with another man named David. I know I was; but since I wasn't looking to stand beneath the *chuppah* when I approached him, I didn't let it bother me. At that moment, I was looking to get done in front of the crowd gathered there at the Catacombs, San Francisco's premiere SM club.

We made small talk and I casually mentioned that I liked his boots, that I would like to lick them and to be his slave—if only for that night. He nodded and said, "Maybe later." This didn't put me off. Even while I watched him play with a friend of mine, a boy who just had recently posed for Colt (his life-long ambition at that time), I waited patiently, knowing my turn would come. It did, and later I would write about it in my diary:

> Our scene started out around ass play, but ended-up being centered on bootlicking. He fucked me in such a position that I could lick his boots while he was wailing on my ass. "I'm cumming, Sir! May I cum, Sir?" I asked. "Lick the boots harder, *harder! Harder!*" he commanded. I came, beautifully. Then he said, "Kiss it good-bye, now—as if you mean it!" He told me later on that he'd never been so excited by bootlicking before. I told him that that was because he'd never been with anyone who enjoyed bootlicking as much as I did until that night. Exceptional play.

I also knew from the start that this would be an important conquest, and that a good report from him would assure my being invited back to the Catacombs. Later on I discovered that he was bisexual, with a wife and a male lover. I certainly found this information titillating, and enjoyed telling all my friends that I'd done a married man. David and I would run into each other now and then after that, play at the Catacombs occasionally, but I never let my heart get involved with him despite his many charms. As hard a crush as I had on him, I still wanted no part of the complex web of relationships to which David and his bisexual wife were said to be committed. While hardly a sexual conservative, and certainly not monogamous, I thought this sort of "civilized" openness somewhat dated by, what was then, the early 1980s.

"I don't want to date him seriously under the current circumstances," I told a mutual friend when I'd heard that David had a new male lover. "But it would have been nice to be asked."

A few years later—quite suddenly it seems to me now, but maybe not since I was by then approaching 30—I decided that I was bored with dating an assortment of men and that I wanted to "settle down." Just as suddenly, the pool of prospective partners I was willing to consider as husband material consisted primarily of Jewish men.

It was right after an intense but short love affair had ended that I ran into David at *schule*. I knew my most recent ex-boyfriend would be going to San Francisco's other queer synagogue, so I went to this one that night for no reason other than to worship (something I'd only discovered thanks to this same ex-boyfriend, a man, now dead, to whom I am eternally grateful).

"Are you here with your boyfriend?" David asked.

"No, Jason and I broke up," I answered as casually as I could. I knew already that David and his wife were getting divorced. I had expressed no joy at this news when I'd heard it a few months before, but had secretly hoped ever since that we might eventually get together.

His face lit up. "Well maybe after services we can...?"

"Not tonight," I answered truthfully. "I have a blind date. Maybe next week?"

"Sure," he answered. "I'll look forward to it."

I knew that I was already falling in love with him but held my emotions in check. I remembered something Andrew Holleran had written, that falling in love was like cooking a pot roast and all a matter of timing. I decided to play it cool. I would let him call me first. He did a few nights later.

As much as I looked forward to seeing David, and to having a real date with him, I did not expect to forge any new ground when it came to sex. I was sure I had done it all. Whatever we did sexually, be it kinky or vanilla, it would be sure to be fun sex — just nothing to send new shivers down my spine as my cock unexpectedly hardened anew, dripping sudden expectation. But again, I underestimated David Lourea.

Quite naturally, it seemed, we fell into a Daddy/boy scene. I was spanked for being a bad boy and jerking-off in the men's room

at work, then fucked long and hard as only he could fuck. His cock was only average, but he had a great technique that had me squirming under him, wanting more and more of him as he did his level best to give it all to me.

When he'd finished fucking me, he rolled me over in his arms and held me while I wanked-off. One hand's fingers played with my prostate while the other pulled on my nipples. Then I heard the words that sent me where I never expected to go again.

"*Sheyna boychick.*"

All the time I was jerking-off, he murmured to me in Yiddish: I was his *sheyna boychick;* I was as pretty as the moon; I was my *tate*'s darling. Suddenly *Mamma Loshn* felt like a forbidden tongue, the language of our most perverse desires. My cock was rock hard. I cried out as I shot my load over our shoulders where it hit the headboard behind us several times in rapid succession.

"*Tate!* I'm cumming *Tate,* I'm cumming!"

"That's a good *tatela.* Make *Tate* proud..."

The rest of that night, being held tight against his hairy body as we slept, I felt dirty and excited at the same time. It was as if we'd done something blasphemous—only it was something we could feel good about because it only *felt* forbidden.

We rarely spoke about our new language of desire, however, even between ourselves. It was our secret, and one we hardly dare mention even when we were alone together. We only spoke it.

What I did not know until then was that Yiddish had been his first language. Raised by his grandmother until he was five years old, Yiddish was all he spoke until he was sent to kindergarten where he learned English on his own. While roughly the same age as my eldest brother, he was still my *Yiddishe Tate*, the embodiment of an implied but fictional incest that became the finest expression of what would be our love.

Any boy honest enough to tell you about belonging to his Daddy will also tell you that part of the appeal of being a boy is, after all, how dirty it lets him feel. It is the naughty secret that becomes the sudden bemused smile coming out of nowhere the next day in the office, or sitting on the streetcar home, or between sets of bench presses at the gym.

Was I in love, friends asked, or just well fucked? I couldn't tell them at first for fear of spoiling something so precious that it

defied all language but it's own perverse logos. Eventually everyone knew about us. We were an established couple before long, known to be kinky and with a reputation far wilder than anything we could ever have lived up to in our real lives.

We often played publicly over the years, mostly because I enjoyed it so much. We played either at different SM clubs, or at the leather bars along Folsom Street, or at friends' private parties where we were always expected to give some kind of performance. At these times I called him Sir, Master, or Daddy as I knelt at his booted feet on the end of a leash. Only in private did *Mamma Loshn* become *Tate Loshn*, the words we etched into each other's hearts.

Eight years later, while he lay dying, it was in the broken Yiddish phrases that he had taught me that I tried to express my love for him, hoping *Mamma Loshn* would penetrate the silence of his final coma where mere English could not.

THE MINYAN

Lawrence Schimel

Simon felt self-conscious as he walked down East 10th Street. He wondered if everyone could tell that he was going to a sex party, which was a ridiculous thought since it was a private party being held at someone's apartment. It wasn't as if he was going to one of those clubs where anyone watching him enter or leave would know what he was up to.

Still, he felt like it was obvious. Which may have simply been because he was nervous. He didn't usually go to sex parties, but one of the guys from Congregation, Uri, had invited him. Simon had spent the rest of the service wondering which of the other guys Uri had invited as well. He'd found himself mentally undressing the men around him, wondering what they would look like naked, how big their dicks were, if Isaac was hairy all over, thick matts of fur covering his body. He'd imagined them in all sorts of sexual poses and situations.

As if he didn't feel that these thoughts—so improper in shul—were sacrilege enough, Simon had been embarrassed by his body's behavior, the fact that he'd had a hard on pressing its way outward in his pants every time he stood. He'd felt like he was back in high school, getting a woody on the way to class and holding his schoolbooks in front of his crotch, as if everyone—especially all the other guys—didn't know what that meant. The instinct to shut the siddur and hold it protectively in front of his crotch, to sheild his erection from view, was still strong, but Simon resisted. He recited the responses from memory, his vision blurring as he nervously glanced to his left and his right, trying to see from

the corners of his eyes if anyone had noticed his arousal. He was grateful for the fringe of his tallis, which hid his boner behind its white veil, although he was afraid that his hard on was making the fringe stand out as well.

Although he was not certain who among the congregation was also invited—the way one did not know who exactly the lomed vuvnick were—Simon had skipped services two nights ago because he felt too ashamed about seeing those men there and knowing what they planned to do this evening. Or what he imagined they planned to do; Simon wasn't quite sure what it would be like, since he didn't often go to this sort of party. In fact, he'd never been to one like this, although he had once been to a "sauna" when he was down in Puerto Rico on vacation. He'd been fascinated to be in the presence of sex, to watch men around him sucking and fucking in public, but he'd been too nervous to let anyone touch him, let alone do anything more. Men did touch him sometimes—the rules seemed to be touch first, ask later—but Simon always shied away from the groping hands, the men who tried to sink to their knees before him. He'd fingered his own dick behind the protective curtain of his towel, too afraid to show it off in public despite the naked bodies all around him, and he came almost immediately, shooting into the terrycloth fabric. He went back to his little cubicle room and turned the towel inside out, so that the cum-stained side was not against his skin, all sticky.

But he did not leave.

He had felt a compulsion to stay as long as his time would permit and to watch as much sex as he could. It had taken days of rationalizations and justifications to talk himself into coming there, and he'd done it only because he was so far from home—almost in another country, for all that it was technically a territory of the United States. He'd always been curious about the sex clubs back home in New York, but he was always afraid that if he went to one he'd run into someone he knew. It didn't matter that they would both be there for the same reason, Simon would just die of embarassment if that were to happen.

So now that he'd convinced himself to finally visit one, he stayed in the bathhouse in Old San Juan for hours, pacing the halls, exploring every room and alcove, always watching, silent, not talking to anyone—whether they spoke English or not. He just

wanted to be there.

Hours later, in a backroom that was pitch black, Simon did let them touch him. He didn't know how many men there were—he couldn't see them, couldn't see anything. Somehow, as long as he couldn't see them, it was OK. It was like his friend Eric who talked faster and faster whenever he lied, as if he hoped that somehow God wouldn't hear his falsehood if Eric talked so quickly.

It didn't make any sense, Simon knew, but he stopped thinking about it. When a hand had touched him in the darkness, he did not jump back. He let it explore, slowly working its way down his chest to the barrier of his towel, tightly wrapped around his waist. The fingers pulled on the flap tucked away, and Simon grabbed the towel before it fell to the floor, clenching it in hands—to give him something safe to hold onto as the fingers continued to explore, and touched his cock.

Because he couldn't see anything, Simon was able to imagine whatever and whoever he wanted. He was too afraid to do any-thing to anyone else, although he did from time to time reach out with one hand to feel the bodies of the men around him, the invisible men whose hands and mouths were touching his body, and there were always too many hands or mouths on him, always more than one man. His fingers would venture forth (the other hand still tightly clutching the towel like his own version of Linus' blue security blanket) and touch flesh, drop down to feel the man's cock, then retreat back to the safety of the towel, wiping off the droplets of precum that had clung to his palm.

Simon had wanted to pull back, when he came in someone's mouth—he didn't know whose—thinking, "This is unsafe, you shouldn't do this, you don't know who I am." But it was too late. Before he knew it he had crested over into orgasm, his hips buck-ing his cock deeper into the stranger's mouth, and the man grabbed his ass, pulling Simon toward him, not letting go until his body had quieted again and his cock had begun to grow soft in the guy's mouth.

Stumbling over the bodies around him in his hurry to get out of there, Simon had practically run to the showers and scrubbed his body pink, then went back to his hotel. That was all nearly two years ago now, and he had never been involved in any

sort of group sex before or since. Until tonight.

Because he was nervous, and had been building up this moment in his mind for so many days now, Simon was sure that everyone could tell that he was on his way to have sex.

He was also horny. He hadn't jerked off for the past two days, even though he normally jerked off at least once a day. But he had developed this sort of superstition about not jerking off on the night before he was going to have sex, or when there was the possibility of his having sex, such as if he were on a date. Or going to a sex party.

Part of it was simply performance anxiety. By "saving up" he felt more secure that he would get hard quickly, no matter how nervous he was, and also that he would have an impressively thick cum.

He arrived at the building and stood before the door. This was his last chance to turn back.

But Simon wanted to be here tonight. For all his wanting a boyfriend, looking for a mate who'd be his life partner, for all his reticence at the sauna in Puerto Rico, Simon knew that he could so easily become addicted to such promiscuous sex. There was a part of him that craved that wild abandon, to have sex with many men in a single night, to not know or care who they were or ever see them again.

He hoped that tonight, among these men whom he knew and who, moreover, were his people in so many ways—fellow jews, all with the same sexual desires he felt—that he'd be less nervous, more willing to let himself try things he'd only fantasized about. To be part of the groupings of bodies he had only witnessed last time.

Simon cleared his throat, hoping his voice wouldn't crack when he had to say his name, then pressed the buzzer. After a moment of waiting, he heard the click of the door being electronically unlocked, without anyone asking him who he was.

This made Simon a little more nervous. Just how many men were invited to this party, that they let anyone up? Or was he simply the last invitee left to arrive?

He rode the elevator wondering if men were already having sex or if they'd waited for him before starting. As he stared at the floor numbers going up and up, he shifted his hardon in his jeans, willing it to go down. He thought it would seem improper to have

one before he arrived and disrobed, as if he were so hard up and desperate that he couldn't control himself.

Arrows indicated which wing each set of apartments was in. He pulled the invite from his pocket and checked the number, then put it away again. He stood before the door and rang the buzzer. Simon could hear men's voices inside, chatting. He wondered if soon the neighbors, anyone passing by the doorway, would be able to hear their sounds of sex.

Simon heard the flap on the eyepiece being lifted. He smiled, although he always felt he looked ridiculous through those warped fishball lenses. He took his hands out of his pockets. Uri opened the door. It's strange to be greeted at the door by someone you know only casually who's wearing nothing but his BVDs. Especially when you're not used to seeing them in this state, such as if you went to the same gym and saw each other in the locker room all the time.

Simon couldn't help looking him over, up and down, staring at Uri's body. He was short but solid, with thickly muscled arms and legs. His skin shone like burnished bronze, and he had wiry black hairs in a line down his chest and covering his legs, like sparse grass poking up through desert sand. He'd grown up on a Kibbutz in Israel before moving to the US five years ago.

"Shalom!" Uri cried, leaning forward to kiss Simon on the lips in the typical gay greeting. "The party's just getting started," he continued, "come on in."

Simon reached out and kissed the mezuzah on his way into the apartment.

Uri lived in a nice one-bedroom condo. He had a large abstract painting over the livingroom couch, under which sat three men, also naked except for their underwear. They all looked sort of nervous, and sat separate from each other even though they were all on the same sofa; nowhere did skin touch skin. Simon nodded to Benji, who he knew, and then looked away, blushing because of how Benji was (un)dressed and what they were planning. He had to suppress a barely controllable urge to giggle.

There were other men, also in only their underwear, standing with their backs to Simon, looking at the books on Uri's shelves. Two of them had kipahs on, pinned to their dark hair.

Uri led him into the kitchen. "Take your stuff off," he said,

pointing to the stacks of neatly-folded clothes on the countertop. "What do you want to drink?"

At other apartment parties, everyone took their coats off and left them in the bedroom, then congregated in the living room.

But tonight, the bed was going to be put to better use. And so, for that matter, was the living room.

There were six other guys there so far, besides Simon and Uri. Simon knew three of them from shul—Howard, Stanley, and Benji—although he'd never seen any of them naked—or nearly naked—before. They hadn't been among the guys he'd been mentally undressing that night Uri gave him the invite, but they didn't look bad without their clothes on, just sort of average: dark-haired, dark-eyed slavic Jews who didn't get much sun.

Of the rest of them, there was one guy, Darren, who Simon had met before at a gay Yeshiva dance. He was tan like Uri, but his body seemed hairless. It was only later, when Simon was closer, that he realized Darren had shaved himself, even his crotch.

The other two guys, Ezra and Joshua, Uri knew from when he lived uptown and went to the gay congregation up there. Joshua was a redhead, whose arms looked too thin. Not at all Simon's type, but then he'd never understood the fascination many men seemed to have for redheads. Ezra, on the other hand, was the kind of boy who might catch his eye on the street, with his dark eyes and goatee and v-shaped torso. It was a surprise to Simon to learn that Ezra was so shy and unsure of himself, sort of nerdy, hiding behind his glasses the way Simon felt that he, too, did quite often.

Everyone was in their late twenties or early thirties. And they all seemed nervous, or unsure of what they were or should be doing. Everyone except Uri, the mastermind of this little get together, who walked about with complete comfort, unconcerned about his near-nudity and the sex that was on everyone's mind. He played the host, but also seemed completely at ease, chatting with his friends as if this were any ordinary get together.

Since few people knew each other, no one knew really what to talk about.

"It's funny," Howie said. "My mother is always after me, since all my boyfriends are blond and blue-eyed. If you have to have sex with other men, she asks, couldn't you at least find a nice Jewish boy? And here I am, in a roomful of guys she'd approve of, only

not about to do anything she'd approve of!"

It was the wrong thing to say, really, Simon thought. No one wanted to be reminded of what their parents would think of they were about to do, for all that everyone there was eager for it all to begin. But what would happen when they ran into these men again in their regular lives? How could Simon ever go back to shul if he saw Stanley, tonight, with a stranger's fingers up his butt? He would never be able to see these men again without remembering what they looked like naked.

The silence stretched on uncomfortably.

Darren told a joke: "So this kid comes home from school and says, 'Ma, Ma, I got a part in the school play!' And the Mother says , 'That's nice dear, what part did you get?' So the kid tells her, 'I got the part of the Jewish husband.' The mother stops what she's doing and looks at her son. 'What's the matter,' she says, 'you couldn't get a speaking role?'"

Everyone laughed.

The buzzer rang. All noise stopped suddenly and everyone turned to stare at the door, even though whoever it was had to come all the way upstairs before they got to the door. They were all wondering the same things, Simon knew: would it be someone they knew or a stranger? What if this new guy was ugly? What if he was unbearably cute?

Even though only Uri knew everyone there, it was like they were all tired old regulars at some bar, just waiting for fresh meat to show up. Was that how things would happen: one time someone would come in and catch someone's eye and make their move, breaking the ice for everyone else to start having sex? Who would be the first to do something?

Uri looked through the peephole of the door, then opened it. Simon could see from where he was that there were two people on the other side of the doorframe.

"Aaron," Uri said, "what a pleasant surprise. You should have told me you were bringing someone."

"It was sort of a last minute thing," Aaron said. "Jorge, meet my friend Uri. Uri, this is Jorge." He smiled at Jorge, then looked back at Uri and winked. "We met at Escuelita last night."

This was one of those moments of sex party etiquette. Or perhaps simply party etiquette. What to do if someone brought

someone who hadn't been invited? At a normal party, this sort of behavior was usually more forgivable.

Uri looked over Aaron's friend and evidently decided he made the cut. He invited them both in and led them to the kitchen to shed their clothes.

The whole nature of the party seemed to change with Jorge there. It was the presence of foreskin in a roomful of circumcized gay men. It was the presence of a non-Jew.

Simon remembered how his uncle Morty used to always joke, "Shiksas are for practice," whenever he asked if Simon had a girlfriend yet.

Simon didn't doubt that this sheggitz would get as much practice as he wanted tonight, since every guy there seemed to be utterly entranced by Jorge's smooth dark skin as he stood in the doorway of the kitchen—to show off, still visible to the rest of us?—and peeled out of his clothes.

Once stripped down to their Calvins and 2(x)ist briefs and holding their cocktails, they came back into the other room. There were ten men now crowded into the small area, sitting or standing around awkwardly.

"Hey, we've got a minyan now," Howie said. You could tell he was happy to be the first one to notice.

"Actually, we don't," Ezra said. And technically he was right; Jorge didn't count.

But that was for prayer. For a sex party, ten bodies—regardless of their religion—was enough critical mass to get things going. Uri circulated, introducing people and drawing them into conversation. Not everyone could fit comfortably in the living room—at least, there weren't enough places to sit. So some of the guys had drifted into the bedroom. Where they'd started to get it on while no one—at least, not everyone—was looking.

Of course, the moment one of the livingroom group noticed, everyone rushed to the doorway of the bedroom to watch.

Somehow this didn't seem to be the right sex party etiquette, but it didn't stop anyone.

Simon watched the back of Joshua's head bobbing up and down before Stanley's crotch, as if Josh were davening, and perhaps this was like prayer for Joshua, lost in a trance of cocksucking.

With all of them crowded there at the door, growing hard

from their voyeurism if they hadn't been already, it didn't take long for the rest of the guys to start touching one another as well. A hand on thigh or belly, fingers cold with nervousness. A hand cupping an asscheek through the fabric of his underwear. Simon didn't really know who was who but it didn't matter. His heart beat faster, he felt a tight constriction in his chest from nervousness, then he took a deep breath and relaxed into the sensation of his ass in some man's palm. He thought for a moment back to that bathhouse in Puerto Rico, where even though he'd wanted to he wouldn't do anything except in the concealing darkness of the backroom, as if sex were something too shameful to be seen. Among these ten men, these other gay jews gathered together for the worship of the body, he no longer felt guilty about his desperate yearnings for sex with other men, as he had on the walk over here and on so many occasions previously. He looked around him, at the men who were so like him, now lost in their pleasure, the giving and the receiving of it, and he smiled. He was not alone, and he was glad to be part of something bigger than himself, this Minyan, which for him is what it was even if one of the men was not Jewish. A Minyan of desire, men who no longer needed to congregate in clandestine secret to worship, but who could love and pray without shame.

"Amen," he whispered, and pressed himself back against the man who cupped his ass, no longer holding himself apart.

DOWN, DOWN

David O'Steinberg

If a man also lie with mankind, as he lieth with a woman, both of them have committed an abomination: they shall surely be put to death; their blood shall be upon them.—Leviticus, 20:13

If they [the ultra-Orthodox] have total control, they will rule everything by halachic law—that is, according to the Bible laws. It will be setting back women's rights by hundreds of years, not to mention gay rights. We are talking about personal freedom here.—"Jerusalem's Other Religious War," San Francisco Chronicle, March 13, 1995

Let him kiss me with the kisses of his mouth; for thy love is better than wine....My beloved put in his hand by the hole of the door, and my bowels were moved for him.—The Song of Solomon, 1:2; 5:4

We stood in a tunnel of shadows cast by tall, over-arching bushes. A waxing moon, nearly full in the clear sky overhead, cast pools of moonlight everywhere. The warm mid-November night was my next to the last evening in Israel after three months.

"I want go down—down, down," he said in basic, Hebrew-accented, English, right palm gesturing toward the ground. "You understand?"

The apartment on Ezekiel Street in North Tel Aviv where I was staying was only a fifteen minute walk from the park. My lover had gone out for a late dinner with friends in the Florentine neighborhood of South Tel Aviv. I stayed in, packing for our return to San Francisco in two days. After an hour and a half though, I'd had enough of wrapping and sorting through souvenirs from the Old City of Jerusalem, deciding which favorite rusty stones from Sinai I'd take and which I'd have to leave behind—a big confusing

pile of *things*. Where was the real experience of Israel and Sinai in all this *stuff*?

Even three months in Israel had passed quickly, tomorrow was our farewell party, and tonight was my last chance to cruise Independence Park. The place where I'd met Moshe and Avi and Yossi and Uri and others whose names I never learned, but remembered my moments with them...such moments. I wanted more to remember before I stepped onto that plane.

I showered, got stoned, and walked toward the park, looking over the outdoor crowd at the Café Nordau, the local queer cafe. At the stoplight, a car blared "Deep Blue Evening" by Israel's favorite diva, Rita. I had heard the song so often it had become my Israeli theme song. Now its pulsing, sinuous bass line and syncopated beat boomed out into the night to accompany me as I hurried toward Independence Park, my favorite cruising ground in Israel. The park stretches for several acres north and south, parallel to a series of beaches below—one the infamous Hilton gay beach. Yet another is for Orthodox Jews only. The first time my lover and I tried to find the gay beach we went to the Orthodox beach first thinking it was the gay beach—nothing but men in sight. But not quite the kind of men we were looking for. Later, Ruven found out it was men's day there—Orthodox men and women don't even swim and sun together.

Now I crossed the broad boulevard of Hayarkon Street and sauntered across the street-lit entrance to the park. Ahead, a flight of wide, white stone steps led to a red, square sculpture by Calder and the seaside path that runs the length of the park atop the bluffs. I wanted to see the moon on the Mediterranean, but chose to head first for the park's interior, swathed in shadow and moonlight, full of men walking or standing, a few talking quietly here and there, but mostly men not talking, just strolling, loitering, looking, looking, looking...

Israel. How could it be that I would leave all this in less than forty-eight hours? These dark-skinned, dark-haired Palestinian and Israeli men everywhere—the beauty of black hair on olive skin, swarthy faces and five o'clock shadow on the cheeks of soldiers, on the faces of Arab men in the old city of Acco, the dark hairs on the hands of Palestinian men selling me falafel and humus in the Old City of Jerusalem, the sight of two young Israeli soldiers in uni-

form on the beach one afternoon, stripping to their briefs and plunging their muscular bodies into the Mediterranean, swimming around near me, but never quite making eye contact...I still wasn't ready to leave this beautiful, embattled country.

After cruising around on the park's open lawn, I strolled through bushes to the seaside path and looked at the moon on the sea, on the slender white strip of beach running south toward old Jaffa's hilly clump of lights, saw the planes patrolling up and down the coast in this country where too many men were busy trying to kill each other. "Everyone's already living here...can't they all just get along?" I had often thought in my naive, American way. Just get along to the nearest park and kiss each other with pleasure and fuck each other's butts and suck each other's cocks instead of shooting stone throwing demonstrators, or blowing up buses full of people.

My desire for all these Middle Eastern men was inextricably intertwined with the violent events of recent weeks. I couldn't tell who was Palestinian and who was Israeli, only who was attractive and who wasn't. I joked that I'd spun my head around so many times for another look that I'd need to see my chiropractor when I got home. No exaggeration either, but this was Palestine—Israel as I sometimes called it, where all my black and white political ideas had dissolved into layers and layers of gray permutations, contradictions, uncertainties. I thought three months of living here would help me understand the political situation, but all I'd learned had only complicated my understanding. My head would spin from the contradictions and I would long to set aside the politics, the hatred, the threat of violence and simply cruise the man-filled park, to listen to the waves below, to drink in moments of quiet, to sink to my knees before yet another everyday beauty...

I zig-zagged—*chic-chac*—back to the north end of the park and entered a maze of bushes where I had met my first Israeli man dressed in a black t-shirt and tight, white jeans that I'd unbuttoned and peeled down to reveal a smooth Israeli bubble-butt. He surprised me when he turned around and offered me his ass right there in the bushes. I was glad I'd brought condoms and lube with me and went right ahead and fucked him as he leaned against a tree trunk while only feet away men strolled by. I hoped that night's luck would visit me again as I roamed the paths where I'd

met Yoram.

I strolled back to the open lawn where a man glanced over at me and away, then looked again and walked boldly toward me, hands jammed in the pockets of his jeans. He was dressed in jeans jacket, plaid shirt, faded blue jeans, shorter than me, handsome, younger. Short, thick, black hair, olive-skinned, intense dark eyes, a direct look that didn't waver as we passed each other. I looked back to see if he'd stop, but he walked on, not interested after all, I thought—but then he turned to look back, stopped walking and held his gaze.

I nodded toward the nearby maze of bushes, then walked in while looking back, holding his stare as he moved to enter the maze at the thicket's opposite end. I waited in a hollowed-out niche in the underbrush along the path where it was quiet except for traffic on nearby Hayarkon Street. Two men nearby, illuminated by streetlights, groped, kissed, jerked each other off.

Then I saw him coming down the trail, taking his time, but walking steadily nearer, walking a few feet past while staring at me, then stopping nearby to stand with his feet planted apart. He looked at me. Looked and looked. Was he Israeli? Sephardic? Palestinian? Did anything else matter other than the fact that he was hot, handsome, and interested? Well, yes, safety—I'd been warned about pickpockets in the park, it was less than a month since the bus bombing on the Number 5 that had shocked Tel Aviv, and what if I was in the wrong place at the wrong time? And what if I wasn't? I stroked my groin while looking at him, at his crotch, checking out his interest in me, wanting him, wanting him to want me back.

He looked intently at me and started playing with himself. I walked over and stood near him, reached over to caress his smooth pecs though his half-open shirt. My gaze met his intense, dark eyes. He touched my chest, whispered something in Hebrew.

"*Meda-bear anglit*—do you speak English?" I asked, my best line in Hebrew—I'd had to use it a lot, so I'd really mastered it after three months.

"Yes, some," he said through white gleaming teeth, thick, sensual lips. "I know a place, it's better, you come, ok?" he said. It was nearly the same line the man in black t-shirt and white jeans had said and yes, once again, I did want to go with him some place

better. "This way," he said with a nod and taking my hand, led us out of the bushes and across the lawn to a cluster of tall, interlaced trees that formed a canopy.

We stood in the middle of a tunnel of trees, open at both ends. "Here is better," he said, letting my hand drop. "Not so much peoples." We fell silent. I put my hand on the back of his neck and pulled him to me to kiss those thick lips. Mmm...melt into his mouth.

His chest was firm, muscular underneath his plaid shirt. I unbuttoned it all the way, tugged a t-shirt out of his jeans, slid my hands across his flat belly and slim waist. A line of fine, dark hair ran up his stomach and swirled around small nipples. I sucked and licked my tongue around each nipple, stroked his belly, then leaned back to admire that chiseled chest, those tasteful, understated nipples.

He undid my belt, unbuttoned my 501s, tugged my jeans down as he dropped to his knees, looked up with an intense glance, then slowly, methodically tongued the inside of my thighs, my balls, took my cock between his thick lips, looked up at me as he slid his mouth down the length of my cock, around my balls again, then washed the inside of my thighs and began to nip—and lick—and nip, nip again—lightly at the soft skin inside my thighs, pausing often to look up at me, then licking and nipping more. I moaned, shivered with each bite, each warm wash of his tongue over the skin he'd just nipped. Uh huh, I liked this boy.

After doing both thighs and sucking my balls more, he really went at my cock, sucking it slowly, deliberately, reverently. I held his head between my hands. Heaven was not somewhere else, but here, in this moment, face-fucking this man, savoring the sight of my cock sliding back and forth across the gift of his thick lips. And then he suddenly stood up, kissed me deeply, put a hand on my chest.

"I want go down—down, down," he said in basic, Hebrew-accented, English, right palm gesturing toward the ground. "You understand?"

"Yes," I replied, thinking I understood. "Down here?" I asked, patting my butt.

"Mmm, no now, later, yes. Now I go down, down," he said, looking at me inquiringly. I nodded yes as he sank to his knees, all

the time looking up at me, then prostrated himself on the ground, planted his mouth on my boots, and got busy.

I watched my boots grow wet, wetter as he swirled his tongue and thick lips over one boot, then the other, back and forth vigorously. This young man, whose name I didn't know—knew nothing at all about—gave himself over to my boots with a tongue that licked hard against the toes of my boots, a tongue that slid in long strokes along the length of them. He grabbed my ankle sand tugged them gently to move one foot closer to the other, then ran his mouth wildly from one boot to the other till they were both slick. I stood shocked, stunned—a Jewish man getting his boots licked hard by an Israeli—what did it mean?

For the first time, I understood—or rather felt, in the electric surge through my groin—the thrill of a man licking my boots. Other men had done it, but now I understood it had just been play-acting. Real passion flowed out of this man's mouth, through lips and tongue that urgently licked, bit, sucked and kissed my black hiking boots that only recently had hiked the mountains and high desert of the Sinai. No one had really put their passion into it before, just their mouth, and now I understood something new through his tongue, felt his passion to submit, to worship, through the fetish of the boots in his mouth.

But it was more than mere fetishism with which his mouth worked over my boots. As with the bites and nips on the skin inside my thighs, he looked up frequently from his natural choreography of lick and slurp, and locked his eyes on mine. I stroked my cock and let my eyes penetrate his where he lay, on his belly, mouth on my boots, his butt stuck up slightly, his jeans half-way down his ass. I leaned over, pulled the jeans all the way down to stroke his backside, which looked startlingly like my lover's ass: smooth, round, full, with an exciting down of black hair lining the crack of his ass. I ran my hand over that down again and again, brushing the edge of my palm against his butthole, which made him moan each time, made his mouth frenzy across my boots. Excited by his excitement, I tried a soft smack on his bottom. He didn't object, so I slapped his ass a little harder. "Yes," he whispered between slurps as I alternated slapping his butt with lighter strokes across his sphincter.

When he came up for air, I pulled a rubber out of my jeans

and held it out to show him. He sat up on his knees, chin wet, breathing hard, and gently turned me around, planted small kisses and bites all over my ass, worked his way in till I felt his tongue in my butthole. Good boy—he hadn't forgotten what he said he would do "later." Heaven on earth in the Promised Land again— his tongue licking and probing my sphincter! While he turned up the heat in my ass, I squeezed a drop of lube into the tip of the rubber—for that extra-sensual touch on the inside of the damn, necessary thing, then unrolled the condom down my cock and coated it thickly with lube. When I'd had enough of his tongue in my ass, I turned around to show my readiness, and he stood up.

My lubed hand gripped his cock to masturbate him while I kissed and licked his neck, his ear lobes, one nipple, then the other, then turned him around and pressed up against his backside. He bent forward, hands on knees, and angled his butt out and up at me. Cockhead on sphincter, with the slightest pressure I eased into him—he was more than ready. I slid in deep, eased slowly back out, feeling him open up to me with each stroke. After a few minutes I suddenly wanted him in a different position. "Get on your hands and knees," I said. I wanted to fuck him like a dog on the Holy Land itself, outdoors under the bushes.

I mounted him, locking my thighs tight around his butt, thrusting in deep and fast and then suddenly had the strange sensation that all of me, despite the condom's barrier, was liquefying, as if I was melting through my cock into his ass. I checked the condom—it was intact—then slid back in and fucked him hard, harder. My thrusts forced him down, down until he was flat in the dirt again, where he slipped a hand under his crotch to jerk himself off.

I spread his legs further, opening his ass up to plunge in as far as I could, pulled my cock all the way out, only to shove it all the way in again, fast and hard. A cloud passed over the moon, darkening the shadows around us. Then he groaned and bucked back up onto his knees until I was fucking him again doggy style. He leaned on his left arm, jerking off with his right hand.

I was suddenly close, too close, and then suddenly, all I could think of while I fucked him was the line from Leviticus about a man not lying with a man (and of the Orthodox gay man in Jerusalem who told me that by having sex with a man standing up

rather lying down he circumvented and therefore kept God's law); and also of the verse against casting one's "seed" on the ground, all of which only got me hotter. In the heat of my moment with this man, I knew the lie of those biblical verses, as well as the absolute heaven of physical passion with another man. And besides—I was too excited, and needed to think about something else, like the Bible for a few seconds, so I could make the moment last.

Then he moaned deeply, which set me off and I rammed his ass as hard and fast as I could, dripping sweat. My thighs strained tightly against my jeans, I slammed deep in and out of his ass, my boots dug into the dirt, all of me tried to fuck my way inside him. I gripped his ass with my thighs, grabbed a nipple with one hand, grasped his cock tight in the other, then dissolved into it with him, feeling my cum shoot sharply out of me and fill the condom as I rocked in and out of his butt, fucking him hard into his own intense orgasm, feeling his seed shoot out of my tight grip and all over the ground.

Drained, washed clean in my sweat, I gripped the rubber and eased out of his butt, sat back on my knees, and pulled him up into a hug from behind. After a few minutes we stood and tugged up our jeans. No kleenex. I took his sticky hands and wiped them on my 501s, marking myself with his stuff—it's not totally good sex for me unless I get my jeans or leather dirty, greasy, cum-splattered.

"Whew," I exhaled, "you're a wild boy."

He grinned, boyish embarrassment on his face.

"Would you like this as a souvenir?" I asked, offering him the condom full of cum. He laughed. "No, nice souvenir, thanks—but no."

"Well, I'll decorate this tree with it then," I said, hanging the rubber on a handy branch. He laughed.

"I wasn't expecting anything like this in the park tonight, you're a real surprise."

"I'm not always this way in the park. When I see your boots...I don't see many men here with boots. ... I noticed you," he said in halting English.

"Well, the Israeli army must be hell for you," I said.

"Yes, in many ways," he said. Uh oh. Maybe I shouldn't have said that, but he was grinning at me.

"I was really surprised," I said again. "I haven't met many

guys here who are into this kind of stuff, I mean, there doesn't seem to be much of a leather scene in Israel."

"No, here, not so like America, but I meet some men who like this sex. ... I like leather, boots... and be dominated during the sex...not cruel or with a lot of pain, but controlled by the other man during sex, you understand?"

"Yes, I understand," I said, admiring his honesty and direct-ness about what he liked, a quality lacking in too many of the men I had sex with in San Francisco, but nonetheless I said, "You should come to San Francisco—lots of men in boots there for you to lick."

"Yes, I like sometime come to San Francisco. ... I don't know when, but I like come."

"Lots and lots of boots—and men in leather."

"Yes, I would like this. And perhaps you have other boots too?"

"Yeah, some knee-high black leather boots," I said, mindful of the irony of one Jewish man in knee-high boots being serviced by another Jewish-Israeli man on his knees—or belly.

"Yes, I like," he said. We started walking out of the tunnel of trees toward the open lawn.

"What's your name?" I asked. Why hadn't I met this guy my first night in the park instead of now?

"Avi. And you?" Only a month or so before, when I told someone I'd met an Israeli man in the park named Avi, my friend laughed and said, "Oh yes, in the park everyone's named Avi— it's a very common name, like John or Bill." I didn't care if that was his real name or not. Israel is a small country, I was a complete strange, people are more cautious here where there is no real anonymity.

"Dah-*veed*," I said, pronouncing it with a Hebrew accent before saying plain old American "David."

"You live now in San Francisco?"

"Yes, for fifteen years."

"You speak Hebrew—where you have learned this?"

"I took a class in Hebrew conversation in Berkeley...and my lover's Israeli, so I learn Hebrew from him too."

"Ah, your lover?" he asked, eyes widening. "He knows you come to this park? Where is he?"

"Probably getting fucked in the bushes somewhere in the

park. Yes, he knows I come here. He went to dinner with friends in the Florentine, but by now he's probably roaming around the park too."

He laughed. "You both like going out for the strange man?"

"Yes. The strange and wild man." Our eyes locked again. "You're a wild boy," I said shaking my head, "a wonderful surprise."

"Yes, also you. I'm not always this wild boy...." He hesitated a moment, looked at the ground, then up at me again. "A shame you leave in few days." We had reached the sidewalk of Hayarkon Street. Suddenly, I could feel the edge of my impending departure, sharply. We looked at each other and I shook my head again, laughing a little.

"Avi. The wild boy."

"This night... it's not typical," he said. "I remember this night long time."

"Yes, me too. I will remember it for a long time— my night in the park with a wild Israeli boy." He grinned. Those liquid, dark eyes, his olive skin, thick, black hair. Would he fit in my suitcase? I thought to ask for his phone number and address— but in a few days I would be 9,000 miles away.

"Thanks," I said and leaned over to kiss him, right there on Hayarkon Street, in full view, under the streetlights of Tel Aviv, with people getting into a car nearby. I didn't care who saw this kiss. And said good night to him. I started to walk away, then turned to look back. He was standing there, hands in his pockets, like when I first saw him, watching me walk away. "*Lehit-ra-oat*," I said with a wave of my hand—"see you later."

"*Lehit-ra-oat*," he said breaking into a smile, a trace of sadness in his eyes.

At Ben-Gurion Airport a shuttle takes you from the terminal to your plane on the runway. You step off the shuttle and walk across the ground and wait in line to climb the portable stairs leading up into the plane. As we inched forward, I said to Ruven, "Look, our feet are just about to step up off of Israel." He groaned. This is the homeland he's always a heartbeat and sigh away from in San Francisco. I understand that sigh better now. I looked down at my hiking boots as I lifted them—first the right, then the left—off of *Eretz Israel*.

FROM HIS OWN HANDS

Andrew Ramer

The air in the city of Safed has a bouquet that only some can
smell. It covers the hills and fields and houses with a clear and
crystal fragrance. The sounds of talking and work, study and prayer,
echo through that rare essence, ringing like bells. The air in Safed is
always a presence, never a void. It is filled space, rather than the
emptiness between spaces. It embraces the stone houses that seem
to grow up from the earth. It flows down crooked winding streets
like water from a cold mountain spring. It caresses the people who
live there, and circles around them, whether they can smell it or
not. They move through that city like walking trees, rooted and
holy, laughing, weeping, marrying, birthing, dying, again and again
and again. So is it any wonder, with that holy air, that rabbis and
mystics from all over the world have long found their way to that
city?

Famous rabbis known to everyone have come there to pray,
to teach, to learn. Their study houses and synagogues were
crowded, and none more so than that of the famous Rabbi Yosef,
who came all the way from Greece with his wife and his daugh-
ters. His school was a big one, his students come from even farther
than he, even from so far away as Yemen to be with him. And they
all became like family, living there, learning there, dying there.

Among the pupils of Rabbi Yosef, only Yonatan did not
remain in Safed, city of crystal air, to marry, have children, and
continue to study. He moved back to the house of his father, in a
village half a day's walk outside the city walls, to share in his
father's work, and to continue his trade after his death.

Yonatan and his father were carvers, and they lived by them-
selves near the quarry. They carved inscriptions on lintels, or
flowers or scroll work. They carved spouts and corner stones for

the local masons. But most of their work was in carving tomb-stones, and then supervising their transport and erection, using a cart and two donkeys to pull it. On Saturdays they would walk into the village to go to the synagogue, but other than that, Yonatan and his father seldom ventured in themselves. In spite of the mystic flurry in the air, and the hospitality of Yonatan's former school friends, when he wasn't working with his father, he spent his time alone, wandering in the fields, a book in hand.

When his father took ill, Yonatan knew that he would have to take an apprentice. The work of carving, lifting, setting into place of stones was too much for one man to do alone. One of his old friends was raising his brother's son, an orphan. Aharon was a strong boy, quiet, who did not join the other boys in their games. His uncle did not think that he would mind living away from the city, and when he told the boy of Yonatan's offer, Aharon was grateful, and so was Yonatan, who had buried his father earlier that spring. And had Aharon to help him with the stone.

The sound of mallet and chisel on stone was pleasing to Aharon. Learning a craft was satisfying to him. And from time to time, as his work improved, Yonatan would leave Aharon alone to work, and would set off by foot to Akko, that strange port city, where among the docks and within the walls, affection could be bought for a few moments. But Yonatan would return from each trip a little more lonely, determined each time not to go again. And he would be seen for a while in the city at Rabbi Yosef's syna-gogue, and was once even seen entering the house of Feivish the city's matchmaker. But nothing came of that visit, and after a time, his work would pull Yonatan back again to his shop, and his old friends would not see him.

Far into the night he would work, long after Aharon had gone to sleep in his little loft room. The two seldom spoke to each other, except about work, yet seemed ideally suited to be living together. Over time, Aharon became like a son to Yonatan, and was devoted to the older man who had rescued him and would one day turn his home and his shop over to him.

The two of them would work together, cutting and polishing and loading their carts, heading out to cemeteries for their sad but immortalizing work. Then one day at breakfast, Yonatan would say that he had to go to Akko, and was leaving Aharon in charge. And

the boy wondered why he went, and why he always came back in such a moody state. But Aharon never asked; just wished his master a good journey.

And finally, Yonatan reached a moment, groping for someone, when the shame was so great that he knew that he could not go back to Akko. He knew the laws and he had violated them. But walking home, reciting those verses in Leviticus to himself, he remembered something that Rabbi Yosef had spoken of to his pupils, a secret that all must know, but none must ever attempt.

One man must not lie with another man, he knew. But the rabbi had told his students the secret for making a man of clay, a golem. And the law said nothing about that. The rabbi said that the formula could only be used in matters of life or death. But for Yonatan, whose soul was at stake, it was such a time, and he headed to the woods, to a place where he knew that he could find fresh clay.

Hands callused, unused to working with such soft material, Yonatan plied the lumps of wet clay, night after night, in the long empty room that used to be his father's. He shaped and molded, keeping the form beneath wet sheets until his fingers became adept at kneading and shaping. Over and over he would destroy what he had made and start again, until the lumps began to re-semble more and more the broken marble statue pieces he had seen in Akko. High cheek bones, thick curly hair, a high bridged nose, the beardless face of a young man, muscles well formed, like a Greek youth, but circumcised, as the law commanded.

For weeks he worked on the statue, night after night, until he knew that his handiwork was perfect. Then, sprinkling it with cinnamon and myrrh, he lit one lamp at its head, and one at its feet. He sat on a chair by its side and recited over and over again the words that Rabbi Yosef had warned his students never to speak.

As the sun rose, just as he was taught, Yonatan wrote a for-mula in the air above the figure's heart, and then poured two pitchers, one of milk and one of wine, over the clay form. For six nights he did this, exactly as he was told not to. And he would run his hand lightly over the statue, feeling the lines of its ribs, feeling the features of its face, running his hand down over the muscles of its abdomen, the navel it never occured to him not to include, lingering over its genitals, kissing it softly on the forehead and the

lips. Then he would cover it with a white cloth, and lock the room again.

By day Yonatan would wander the fields, ambling, pacing, and several times a day he would climb the few back stairs to his father's old room, to find his clay figure exactly as he left it.

On the morning of the seventh day, a Friday, before the sun rose, Yonatan climbed the stairs with a little oil lamp in his hands. The sun's first rays were pressing through the slits in the shutters, like fingers. And in their soft light, as Yonatan removed the sheet, his figure appeared changed. Softer, colored rosy by the sun. When he touched it, with a shock, a hoped for, fearful shock—the youth was warm.

Yonatan held the lamp above it—above him—watching the golden down on his stomach tremble. His other hand shaking, Yonatan reached out toward his creation, sure that he was dreaming. His fingers strayed upon the chest, and then brushed the thick honey colored curls off of his forehead. When he did, the youth's eyelids quivered, and slowly opened. They were brilliant eyes, of a color unthought of by their creator. Eyes turquoise as polished stones from the mines in Sinai. They did not meet Yonatan's dark brown ones, just opened for a moment and then closed again, as the young man's head rolled to the side.

Terrified, Yonatan felt for the pulse. A tombstone carver is often called upon to attend to other aspects of Death's work. The boy was alive. Thanking God, Yonatan covered up the youth, and afraid to leave him, sat down in his father's chair.

His mind was racing. How would he explain this to Aharon, to the people in the city? Frantic, crazed, his body was also filled with passion. He wanted this young man desperately, wanted to embrace him, to kiss him, to savor his body as he never could with the men in Akko whose favors he paid for. But Yonatan was afraid. He held back. This was all too wonderful. Too perfect. The kind of thing that can only happen in places like Safed, as rare as the air that blows through them.

Finally, the hour was growing late, there was work to be done, for the wife of a school friend had died in childbed the winter before, and he and Aharon were finishing a double stone for mother and child. The date of the unveiling was only a week away. He got up; then sat down. Could he leave the youth alone? Would

he be safe? And, was he hungry, could he speak, would he try to get up, walk down the stairs? Trembling, pacing, he thought of a plan.

Aharon was still asleep. Yonatan yelled up to his loft, to wake him. Said to come, that he needed help. "I've found a young man in the woods. Hurry. I don't know who he is, or where he's from. I carried him into father's room." Aharon came leaping down from his loft, and followed Yonatan down the narrow hall and up the three stairs to the small room in back. He was startled by the young man, startled by his beauty, by his nakedness, by his coloring, so unlike any that he had ever seen, even in a city that attracted young men from everywhere.

Yonatan was shaking, terrified that Aharon would figure out his secret. Only later, when he calmed down, did he realize how absurd that fear was. But that morning, he was shaking. He could hardly speak, and let Aharon's questions create a story for him. Of how he found him while out walking. And yes, he was naked, and yes, he was unconscious. Who could he be? Probably a student from the city. That made sense to Aharon who ran off to get him some water, some food. And Yonatan took out from a small wooden chest some old clothing that had been his father's. It didn't fit the youth, but it was better than nothing.

Finally, the youth awakened. He opened his gleaming eyes to Aharon for the first time, welcomed the water that Aharon held to his lips, but could not speak, and was too weak to sit up. Yonatan and Aharon took turns sitting with him all day. That evening, Yonatan sent Aharon into town to attend services. He stayed with the youth, who slept on and on.

The news was all over town. A student had turned up in the woods. But there were no missing students. And why was he naked? And where was he from? No one had any answers. But he was there, and he was welcomed.

It was Aharon who carried him about, who taught him to walk, to dress himself, to feed himself, and even over time, to speak. Yonatan was too much in awe of him. Too in love with him. All that he knew how to do was watch him. Watch him. Watch him. At night, he would sit by his bedside, a single lamp flickering, and he would stroke his hand and talk to him, tell him stories, which the young man loved.

Several rabbis came to see the youth. They were puzzled. He had not even a garment on his back, nor could any be found in the woods. He hadn't even a scar on his body to tell a story. And since he had no idea of where he was from, or what his name was, it was Rabbi Yosef who decided to call him Adam. Adam the son of Abraham.

Adam was slow to speak, slow in thought, but quick to learn anything that had to do with his body. Just from watching, he picked up the craft of stone carving so well that Aharon decided he must have known it already. His muscles were made for work. He could lift things by himself that both Yonatan and Aharon together used to struggle over. And on a hot day, when he would take his shirt off, Yonatan would almost pass out from his beauty. He was frightened by one thing; Adam never sweated. But that was noticed by Aharon and others, and taken up as just one more of his mysteries. Who could ever think that a man of flesh and blood, even a stranger unlike anyone the city had ever seen, could have been made out of clay? Not even the rabbis in their wonderings ever thought of that.

Yonatan hungered for Adam. Knowing it was a sin, still night after night he used the same hands that had sculpted Aharon to press his body into pleasure, imagining Adam's hard golden body beneath him. Yonatan ached to tell him how much he loved him, ached for the day when he could finally embrace him. Sometimes, his longing was so great that he would find himself on the road to Akko again, not to buy pleasure, but simply to get away. Leaving Adam and Aharon to work together. Coming home calmer, but still frightened.

Night after night in his bed Yonatan would think of different ways to tell Adam. Over and over again he would decide, "Tomorrow." Until tomorrow came. How could he tell the youth that he made him, that he made him to love him? He was sure that if he were gentle and tender, or if he were strong and forceful, or if he were passive and inviting, or if he were any of a thousand different things, that everything would come to pass just as he intended. Should he throw himself upon Adam while he slept? But what if he frightened him? Then all might be lost. For Adam was stronger than Yonatan. And Yonatan knew that rape was not love. No. He would wait. He would wait and see if Adam came to him, his creator.

And the weeks went by, then months. Adam began to speak more clearly, and began to move more easily. The summer sun tanned him, and lightened his hair. In clothes too small for him, he was even more beautiful then when he'd been created. He hated his clothing and hated the caps and hats that Yonatan made him wear. Didn't understand them. "Why?" he kept asking, like a child half his age. But he honored Yonatan as the one who had found him, saved him. And he trusted Aharon as the one who had taught him how to be a person.

But Yonatan's desperate hunger grew stronger as the summer heat increased. He could hardly stand next to Adam without touching him, brushing against him. Staring at him until Adam, who didn't understand that this was not polite, was still made uncomfortable, and would look away. Look toward Aharon, inquiringly. Who did not understand Yonatan's agony, and would smile back at Adam, which tortured the man.

One morning, while Yonatan was sketching guidelines with charcoal on a new stone, Adam and Aharon went for a walk in the woods behind the house. Adam loved the woods the way that children love their mothers. That was all that he knew about his origins, that he came from there. Yonatan had heard them go out, and was enraged. The two of them together, one an orphan, the other a golem, were spending more and more time together. He began to work on the new stone, but he was too distraught. Throwing his tools down on the floor, he ran out to find them.

Out of breath, following their footprints, Yonatan caught up with them near the tiny stream where he had gathered the clay used to shape Adam. He stopped behind a tree. He froze there. The two of them were standing facing each other. They were talking, but so quietly that he could not hear them. When Adam reached a hand out to Aharon's face, the boy smiled and stepped closer. Adam reached out his other hand, reached out to the first other eyes that he had looked into, and pulled Aharon closer. Then he leaned down, for he was taller, and kissed the boy.

A dagger plunged into his heart, Yonatan clutched the tree. Dug his nails into its bark, and began to shake. First he wanted to

die, then he wanted to kill Aharon, then he wanted to burst between the two of them and draw in the air above Adam's chest the formula that would turn him back into a man of clay. Then he wanted to kill himself, and then he started to cry.

How did he get back to the house? He never knew. When did he fall into a chair in the work room, sobbing in the hands that had made the youth who broke his heart? That heart was pounding, and he could hardly breathe. Gulping for air, drawing into his body the pure crystal air that flowed like liquid silver down the slopes and hills of Safed, something changed in him. Something died, was buried, and something was reborn.

Over and over in his mind he replayed that scene, of Adam and Aharon kissing. He wasn't angry anymore. He looked at Aharon in a new way, for he had never seen anything but a boy, his apprentice. But standing under that tree, Yonatan could see how years of hard work had strengthened him, had turned him from a skinny little boy into a handsome young man.

No wonder Adam loved Aharon. He had been tender, he had taught him. No, something died in Yonatan and was reborn. From that moment, as Aharon's protector and Adam's creator, he determined in his heart that they would have what he never did. When they returned home he had prepared lunch, set the table with their best plates, even put out wine. He never told them what he saw in the woods.

The two young men were nervous, startled. But from living with Yonatan they knew his strange moods. And when at the table he lifted his glass to bless them both, they could only look down at the table, sheepishly. And reach hands for each other under those rough wood slats. Like a guardian, an angel, Yonatan devoted himself to the two young lovers. He protected them from the world, and that protection gave him more joy than any of his trips to Akko.

It was Yonatan who casually mentioned one morning at breakfast that it was time that Aharon move out of the apprentice's loft, and asked Adam if he would mind sharing what had been his father's room. For he'd heard footsteps night after night, creaking, squeaking, trying to not make noise, climbing down and up the ladder, tiptoeing down the hall. And it was Yonatan who went into town one day by cart to see Rabbi Yosef, who was old now, to have

him prepare the document that would leave his house and workshop, his cart, his donkeys, his land, to Adam and Aharon equally. At dinner that night he presented the papers with the official seal to the two of them. Who embraced him as loving sons embrace their father. But what sons have such a loving father as Yonatan? Like twin suns, basking in Aharon and Adam's love had healed him...

And in that house, there was joy. The carvings the three of them made were more beautiful than anything the people of Safed had ever seen. Several years later, when Yonatan died, peacefully in his sleep, Adam and Aharon erected the finest monument they had ever made, on his narrow grave. The two continued to live in that house, work in that house, loving each other. And sometimes at night, they would lie awake in bed, making up stories about where Adam had come from. India, China, places they had heard of only in stories. "Maybe the moon," Aharon said one night, as its silver hands caressed them both through the open window, growing old together, and happy.

THE GOOD SON

Brian Stein

Only later, when we were on the airplane bound for Toronto, did I discover that it was his mother's idea. All I knew when I got home was that Noah had bought two tickets to go to Toronto for the funeral.

"You could have at least told me," I said. I had left work early when I received his call.

"What's to tell?" Noah replied. "It's my father. I knew you'd want to be there."

"Of course I want to be there for you, but, Jesus, the family hasn't even met me."

"So they will now."

He stepped forward and held me close. "Don't be mad. I'm really going to need you with me," he said.

For the next half hour, I arranged for a temporary replacement at work. The library had a bereavement policy so at least there was no problem with time off. Noah's arrangements were more complicated. He was booked solid at the clinic, and rescheduling medical appointments always created stress. He phoned a number of patients personally to apologize and reassure them that he would be back in a week. When he finished, I put my arms around him and held him closely.

No one met us at the airport. No one was expected to meet our plane so Noah wasn't surprised. He thought perhaps his sister Diane might have taken the initiative and sent her son to pick us up. We wound up taking a limo to Mrs. Wolfson's house.

"Noah," his mother cried as he stepped through the door. "I'm so glad you're here." She broke into sobs as they held each other.

From where I was standing in the hall, I could see the rest of house. On the periphery hovered several strangers, both adults and children, who I assumed were Noah's sisters and their families. They stared in my direction, quiet and motionless.

Finally, it was Mrs. Wolfson who broke the silence. "Forgive me," she said, turning while still in Noah's embrace. "You must be Patrick."

If only it had been that simple, that straight-forward. If only his response when he received word of Mr. Wolfson's death from his sister Diane had been no more complicated than booking the tickets and arranging time off from our respective jobs.

"It's not as if I can't afford it, Patrick."

"That's not what I'm referring to, and you know it," I said.

"What, then? Everyone else will be there, why shouldn't you be there with me? You're my family."

Everybody included Noah's two sisters Lenore and Diane, their husbands Harvey and Lev and the three children who'd rarely had the opportunity to address Noah as "Uncle." And of course, Ellen Wolfson, Noah's mother.

"Don't you think arriving home for your father's funeral with your lover in tow may raise a few eyebrows?"

"It's not as if they don't know about you. They just haven't met you yet."

"The way you've described your family, Noah, do you think it's fair to your mother to thrust me into the middle of a death in the family?"

"Look, she's had five years to work through her feelings about you. Trust me, my mother won't dismiss you when we arrive."

"Noah, she hasn't exactly welcomed us with open arms for chicken soup on Friday night. What makes you think she's going to warm to me when I show up for her husband's funeral?"

"Because my mother's not like that."

"Are you telling me your mother's so hip that she won't insist we sleep in separate rooms?"

"In the Jewish faith, mourners are expected to abstain from sex."

"Then wait till your family finds out I'm not even circumcised."

"I admit there are plenty of strange practices surrounding

death in the Jewish religion, as you'll discover," he said. "But dropping your drawers to show your pedigree isn't one of them. We'll cover your foreskin with a yarmulke and no one will be any the wiser."

Noah, like most Jews I'd met since moving to Montreal from St. John's, had an off-beat sense of humor. But even I was surprised that he could make a joke about our imminent arrival in Toronto.

"You're impossible," I said.

"Then it's settled. You're coming home. The flight's at nine o'clock tomorrow morning."

"You're sure about this?"

"Listen to me, Patrick, you are not an embarrassment to me. There is no reason for me to hide you from my family. I love you and I'm proud of you. If they can't deal with my Catholic partner, that's not your problem, or mine. I only wish this was a more joyous occasion for your introduction to my family."

The plane bumped through the clouds into its final descent at Pearson Airport. I held Noah's hand tightly.

"Are you all right?"

He nodded.

"You're having second thoughts about this, aren't you?"

"What I'm thinking about is that until he died yesterday, I hadn't seen my father for the last couple of years of his life. And here I am coming home to his funeral and I feel I don't even know who the deceased is."

"It's only natural for you not to have especially clear or memorable thoughts about your father." Who said a funeral doesn't roil up the past? I thought.

"Telling my family that I was gay caused a lot of difficulties and tensions in our house. My father didn't believe me that I was gay. As if I was making it up, for fuck's sake. And my mother asked my shrink if it was her fault."

"Why don't they just let it alone? We are who we are; it's not a crime."

"I'll never forgive the prick for letting her off the hook so easily. His whole Freudian therapy was based on the idea of strong mothers versus weak, absent fathers. He helps me as a teen to face the reasons why I wasn't a nice normal Jewish boy who laid the shiksas, married the rich girl who couldn't give head if she had a

cock in her mouth and then blows it all by vindicating the one person he'd made out to be the cause of my being such a mess."

"But you know his theories were a crock of shit. If he hadn't fucked around with your head you might have had an easier time coming out."

"Then I might have missed meeting you. Look, I no longer consider it her fault. I don't think it's anyone's fault. But you know, Jewish tradition condemns what we do. It's right there in the Torah."

"And you think us being lovers has my church's blessing?" I said.

"We're the perfect pair, aren't we? Except that it's easier to cross yourself than make a Star of David every time we sin."

"I thought you said you had to refrain from sex."

"Historically."

"Noah, have you given any thought to all that Jewish ritual stuff expected of a son when a parent dies?"

"You mean am I going to say Kaddish for the man who denied my very existence? I don't know." He removed his glasses, aware, almost for the first time, of the enormity of being a Jewish son facing the reality of a parent's death. "You're not worried that I'm going to go through some ethnic thing and rediscover my long-lost Jewish roots, are you?"

The thought had crossed my mind. "When my friend Ben's mother died, Ben became so intensely Jewish he spooked us all out. Last thing I heard he was on his synagogue's board. There's no denying that a parent's death can make a child reevaluate a lot of things."

"I know. It's a conspiracy. First, there's the eleven months of Kaddish and from there it's an easy step to Kosher food, two sets of dishes, the mohel and the Mikvah?"

"The what and the what?"

In five years, my education in Jewish lore had become a source of amusement for some of Noah's Jewish colleagues. I knew all the expletives and I always reminded Noah about any upcoming Jewish holiday. My boss at the library was Jewish and she made a point of keeping me up to speed, almost suspecting that if I lived with Noah long enough I might convert. I would have loved to have been invited to her home for a seder or for a meal in the

lean-to they erect for the harvest holiday, but Noah, for his part, usually acknowledged each holiday's passing with a benign shrug.

He hadn't been a practicing Jew since leaving Toronto, probably even before that, with the exception of Yom Kippur, the Day of Atonement, when, for some inexplicable reason I questioned only once, he still fasted. He didn't make a big point of it; he just shunned food as if a day-long fast was a healthy and medically sound thing to do. Growing up in a Kosher home where dietary laws forbidding the mixing of dairy and meat were strictly adhered to made it impossible even now for him to eat a hamburger and wash it down with a chocolate shake. His favorite food when we ate at a deli on The Main was chicken soup with matzo balls.

There is also a gold scroll with Hebrew writing on the front door jamb, which he insists was a hold-over from the previous owners. He's never gotten around to removing it. Oddly enough, the Star of David on the chain around his neck disappeared soon after we had sex the first time.

"The *Mikvah* is the ritual baths. Orthodox women visit the baths after their period and some men, I believe, go prior to the Sabbath. The *mohel* is the man who made me different from you, if you get my drift."

"If you think I'm going to have any quack doctor perform a little operation on me, you're crazy."

"My aunt Esther's going to love you. She told her husband I'd come out of the cupboard when you moved in with me."

"I think I'm going to love Esther."

"Hold that thought until we meet the family."

"We have a two o'clock appointment at the funeral home," Mrs. Wolfson said as she plugged in the kettle to make some tea. Noah's mother had already put on a black suit. Something about her as she moved methodically about the kitchen and put the cups and saucers in front of us made me think she was in mourning for more than her husband.

Whatever little I had learned about Mrs. Wolfson and Noah's childhood from Noah did not prepare me for our arrival at the house. All the jokes about living room furniture hermetically sealed in plastic, garishly ornate lamps and bad art covering the walls, did not apply in the Wolfson house. Clearly Noah's appreciation of art

and food were not things he'd picked up when he moved out of his home and into his own apartment.

"This does not look like the house that Mrs. Portnoy built," I said as an aside to Noah. "Why have you always led me to believe that Philip Roth was really writing about your family?"

"Never judge a book by its cover, or a house by its tasteful appearance. Trust me on this one. You will eat those words when the family descends on this place for the *shiva*."

"What did you say?" Mrs. Wolfson asked.

"I said, I take it this is the place for the *shiva*."

"Where else would we have it?"

"Since Lenore's house is larger I thought it might be there."

"Sure, sure. She'll have an army of family and friends traipse through her showcase of a home? Not while I'm alive."

Mrs. Wolfson's trenchant sarcasm made it clear that Noah's sister would participate in all the ceremonies but that was as far as she was prepared to go. The *shiva* would be held here.

Lenore and Diane arrived to collect Mrs. Wolfson and Noah. The three of them began crying. Noah remained stoical, accepting that this was his role now as the man of the family. I was not so sure it was the right thing.

"We have to pick the casket and then meet with the rabbi who's conducting the service,"

Noah said. "I don't know how long we'll be. If you watch TV can you please turn it off as soon as we get back? It's another no-no."

"You'll be okay?"

"I'll be fine."

I touched his shoulder reassuringly. "I'll be fine," he reiterated.

The next day, from the moment the limousine picked up the Wolfsons and drove off to the funeral chapel, I was a stranger in a strange land. I rode with Lev, Diane's husband, and Jake, her seventeen-year-old son. Lev was an Israeli, dark and short and hairy and not especially attractive. Jake, on the other hand, had his father's black eyes but his mother's pale complexion; he was as handsome as his father was ugly. The girls would line up for him in a couple of years.

The funeral home was already crowded when Lev drove up and parked the car.

"My God," said Lev, "I didn't think it would be this crowded."

Cars were parked in front and down the side of the building with the remainder of the cars crammed in at the back of the building. When we entered the chapel, I picked up a skull cap and put it on. Lev and Jake went towards the front of the chapel to sit with Diane and the other members of the immediate family while I slipped into a seat near the rear. Noah had wanted me to sit with him but had deferred to Lenore's request that only immediate family should sit in the front pews.

The chapel was almost severe in design. A few ornaments and Hebrew letters provided the only decoration to the stone walls. The casket sat between two light standards and a man reading from a small book sat alone on a chair, keeping watch over Mr. Wolfson's body. Just before the service began, someone attached a small black ribbon to the outer garments of each of the mourners. Then the man attending the casket got up and left.

The eulogy was delivered by the rabbi, a short young man who had a difficult time looking into the eyes of the assembled family and friends of Noah's father. Every time the name of Max Wolfson was intoned, there was a noticeable increase in the sobbing in the chapel. I have no idea what biographical material the family had given the rabbi, but he crafted a very touching, moving portrait of Mr. Wolfson. He seemed like a man I might have wanted to know, even though I knew he'd never approve of me.

Noah was talked about briefly as the doctor in the family. What a great job he was doing as a primary care physician for AIDS patients. His single status was glossed over in place of praise for Lenore's and Diane's children who had given such pleasure to their grandfather. No one had told the rabbi that Mr. Wolfson, husband, father, grandfather, provider, had never accepted his only son being gay. Instead, much was made of Mr. Wolfson helping Lenore's son Richard with his forthcoming bar mitzvah.

At the end of the service, the casket was removed from the chapel and placed in the waiting hearse. The procession wended its way through the suburbs to the cemetery north of the city. The final words of the eulogy were spoken at the graveside and then all males took turns shoveling earth into the gaping hole. The rabbi led, saying that the coffin must be fully covered with dirt before

everyone left. I took the shovel when it came around to me and participated in the ritual. The thud of the moist earth hitting the coffin was heavy and final-sounding. Noah's face lighted up when I handed the shovel to the man on my left. I could now see the ribbon on his lapel. It had a slight cut in it. Later, I would ask Noah the significance of the ribbon.

Mrs. Wolfson seemed lost amid the throng around the open grave. Lenore and Diane each held an arm. The three of them were crying again. At one point, Mrs Wolfson wrenched her arms free and covered her ears. The only one who did not cry was Noah. I knew Noah well enough to know that it would come. It was just a matter of time and place.

Nearly everyone returned to Mrs. Wolfson's house. A stand with paper towels and water had been set up at the front door for everyone to wash their hands. Some of the women who had not gone to the cemetery had prepared a light meal for the mourners: hard-boiled eggs and bagels. I'd never thought of any symbolism connected to bagels but I assumed there was a reason for this austere meal. Perhaps it had to do with their round shape. Noah, Lenore, Diane and Mrs. Wolfson sat on low seats provided by the funeral home. Noah indicated to me that mourners were not meant to be comfortable. In the old days, mourners sat on orange crates.

The full extent of the need to remain uncomfortable came to me when I tried to comb my hair in the bathroom, only to find that the mirror, in fact, all the mirrors in the house, had been covered with a white sheet. One should neither be comfortable nor vain.

Sure enough, Aunt Esther found me and began to pump me about my life with Noah. Her questions had a cheerful innocence, suggesting she thought Noah and I had just set up house. An arrangement, pure and simple, and that was as far as Aunt Esther thought our relationship went. If I had told her that there was more, that we slept in one bed and had sex just like other couples who live together, just like her and her late husband, Mrs. Wolfson's brother, she probably would have blushed and run into the bath-room to take a pill to settle her stomach. Other members of the family were polite, if chilly, when they introduced themselves to me. Was it that my beard gave me an odd rabbinical look they

found disconcerting or had they never seen a man with a diamond stud in his ear before?

There was a quiet period around dinner when only the immediate family was still present. Two large boxes of food were delivered to the house from a caterer. Something about mourners not cooking, I heard Lenore say. Then Noah went to evening services with Lev and Harvey.

I slipped away into the den and was looking at a family album when Richard found me.

"You're my Uncle Noah's friend, aren't you?"

"I'm his companion Patrick. You're Richard?"

"I'm the grandson the rabbi spoke about."

"When is your bar mitzvah, Richard?"

"In November."

"I don't know that much about bar mitzvahs because I'm not Jewish."

"A thirteen-year-old boy gets called up to read a portion from the Torah. I'm learning that right now."

"Is it difficult to learn?"

"Kind of. My grandfather was a big help. He also helped my cousin Amy, Jake's sister, when she had her bat mitzvah." Amy had barely spoken a word since I arrived. The death of her grandparent had been a leveling experience. Perhaps we would have time before the end of the *shiva* to exchange a couple of words, or at least proceed beyond hello.

"You liked him? Your grandfather?"

"Of course. Everyone liked him. He was a very nice man."

To a boy of twelve, Mr. Wolfson was a nice man deserving of praise. He couldn't know that his grandfather was one of the painful reasons Noah had left Toronto.

"I never met him," I said.

"You and Uncle Noah live in Montreal, right? Do you speak French?"

"If I have to."

"Does Uncle Noah speak French?"

"He can. But his practice is almost all English."

"Do you love my Uncle Noah?"

"I do."

"Why don't you love a woman?"

Were these the questions of a precocious nephew confused about his Uncle Noah living with another man or was it something more? I wondered what he had learned about fags at school. At his age it's not always easy to keep an open mind about things that are different. When I had been twelve, everyone thought that two men who did strange things with their dicks were sick or just plain weird. He'd probably been counseled by his parents to be on the lookout for men like Noah and me.

"I love my mother and I do have many women friends. So does Noah," I offered.

"That's not the same."

"I'm not sure if I can explain why I love your Uncle Noah, but I do, Richard, and I'm very happy that's how things have turned out."

"You two will never be able to have children."

There it was: Richard looked at his unmarried uncle and determined that, of all the things society could frown on regarding two men in a committed relationship, never having children was the most pressing shortfall.

"If I thought I might have had a son as intelligent as you, I might be saddened by the fact. But there are lots of other things in our life that, while they don't exactly compensate for there being no children around, still make our being together extremely gratifying. In an over-populated world, producing children is not that important in the larger scheme of things, even if the rabbis and priests insist otherwise."

Suddenly the door to the den swung open. Lenore, Richard's mother, stormed in.

"What are you doing here?"

"I'm talking with Uncle Noah's friend."

"I don't want you talking to him, Richard. Go back into the living room."

"Why?" Richard moved away from me to the other side of the room.

"Hey, wait a minute, Lenore. What's the problem?"

"Richard, this minute, do you hear?"

Richard looked at me, then at his mother and, visibly confused, left the den. Lenore closed the door with more energy than it required.

"How dare you!" she spewed out.

"What are you talking about?"

"Just what were you doing?"

"We were talking. About Mr. Wolfson, if you must know."

"I know what your kind do?"

"My kind? Would that be Newfies?"

"Don't get coy with me. I know all about how homosexuals prey on young boys."

Lenore went straight for the jugular. There was to be no serpentine sentence structure from her.

"I may be a lot of things, Lenore, but I am no pedophile."

"Look, I'm not going to pretend for one minute I like Noah's lifestyle or for that matter approve of the people he calls his friends. I deal with him because he is my brother."

How magnanimous of you, I thought.

"Is Noah aware that you regard him with such contempt and his lover as a child molester?"

"We've discussed my feelings. I thought maybe it was a phase he was going through, but when he moved to Montreal, I realized I had been mistaken. I'm not sorry he isn't living here. Believe me, I'm not. This would break Ma's heart if it was always in her face."

As long as Noah dated women, the fact that he didn't get married was not a big concern to people like Lenore. Noah had accomplished much by becoming a doctor. Even I knew the Jewish clichés about sons going into medicine. But there was something else that was bothering her. There was something not being said. Lenore's lashing out at me was about Noah as well, whether she understood the full extent of her attack; she had attempted to soften the blow by declaring a moratorium of sorts on her blood relative. She was not prepared to cut me the same slack.

"I always assumed that it was only Noah's parents who had trouble with him being gay and living with me. I had no idea you were so consumed with loathing. Certainly not from Noah. He thinks our relationship is okay with you."

"Don't patronize me, Patrick. For Noah's and Ma's sake, I'll attempt some civility for the remainder of the *shiva* and then I'll be quite happy to see the last of you."

"It was your mother who invited Noah and me to stay here."

"I tried to talk her out of that idea, but she wouldn't hear of it. I couldn't convince her that what the family didn't need was baby brother coming into this house with his male lover and embarrassing all of us with—"

"With what? My presence? My difference? Noah's life? What exactly is sticking in your craw?"

"Look, I just don't approve of men sleeping with other men. It's not natural. And as long as my son is at an impressionable age, I don't want him hanging around men like you and Noah."

"Lest he catch something from us? I can see that you've made a a study of this, Lenore. I'm surprised you're not a member of Real Women. You'd be quite an asset to their organization."

"Fuck you. Just stay away from Richard." And with that, she slammed the door shut and departed as angrily as she had arrived.

Well, Noah my love, I thought, putting away the family album, and you said it was only your father who would not acknowledge who you were. Mr. Wolfson was a saint compared to your loving sister Lenore.

When the last guest had left, including Lenore and Diane, Noah let out a sound of deep-seated exhaustion. He got off one of the low chairs that he'd been in all day and sat on a more comfortable one. "I have never been so tired in all my life," he said.

"So why don't you go to bed?" Mrs. Wolfson said. "Services are at eight o'clock tomorrow. Besides, I'd like to talk with Patrick."

"Does Patrick want to talk to you?"

"Sure, why not?" I said. "I think we should get to know each other while I'm here. Don't you, Noah?"

"Whatever you say. I'll see you when I see you."

"I promise not to make it an inquisition," Mrs. Wolfson said as Noah hugged her.

After Noah left, Mrs. Wolfson looked everywhere but at me. If she wanted to putter around to cover her discomfort, there was little for her to do. Lenore and Diane, dutiful daughters both, had made certain that some of their friends attended to a final tidying up.

"I'm worried about him," I began. "He's not grieving yet. He hasn't even gone through the motions. He needs to let it out."

"He will. This has been a difficult time. For all of us. Espe-

cially for Noah."

"I did try to get him to visit, Mrs. Wolfson, but it became a subject that I was forbidden to bring up."

"I guess this was not the best way to meet all of us," she said. "I'm sorry you never got to meet Mr. Wolfson. Max wasn't a beast, you know. He was a plain man who didn't understand how the world was turning out. He may have had a problem accepting Noah's choices, but he never stopped loving him."

"And what about you? Are you reconciled to Noah's being gay?"

She winced. In one small gesture, she let me know that if were going to talk about us, Noah and me, we were going to do it without ever taking the relationship into the bedroom.

"Look, *boychick*, my son tells me he's very happy with you. You're not a bad looking man, and you strike me as intelligent. I wish I could say the same about Harvey and Lev. They're good providers for my daughters and my grandchildren, but neither one of them looks like he walked off the dust jacket of a Danielle Steele novel. But I get *nachas* from them. I can't ask for more."

"You'd like to say that Noah gives you *nachas*."

"I would. I don't think it's an unreasonable request or as- sumption to expect pleasure and pride from a child."

"Neither do I. What would it take to get this feeling from Noah?"

"A grandchild to carry on the Wolfson name."

It all came down to legacy, then. It was so simple, so tradi- tional, except that Noah and I couldn't accommodate her wish. Her grandchildren were the keys to her immortality, and Noah had denied her that. At least in her mind.

"Both sides of our family went through a lot before coming here. Some members never survived the Holocaust. The ones that did still bear the constant reminder, the tattoos on their arms, and the terrible feelings of loss that come with being a survivor. Lenore's and Diane's children will carry on the family tree in spirit, but not in name. That was my hope for Noah, and now I'll never have that."

"Can you live with that, Mrs. Wolfson?"

"I don't know," she said.

"If it wasn't me sitting here having this conversation with you,

don't you think Noah would have found someone else? Would he have been as painful a reminder as, well, the tattoos on your relatives' arms?"

"Meeting you face to face after all this time makes Noah's choice that much more real."

"What choice are you referring to?"

"You see, Patrick, Jews have very specific traditions. About love and marriage and sex within the sanctified relationship of a marriage. We don't promote sin, or approve it."

"Noah and I aren't sinners, Mrs. Wolfson. At least, I hope we're not. I sincerely trust this isn't about morality."

"A good mother would never condemn her children, so you won't hear me speak out against Noah."

"What about me? Would you look at me and cast the first stone?" I paused. She would never get that allusion. I decided on a different approach. "Did Noah ever tell you how we met?"

"No."

"Aren't you interested?"

"Look, Patrick, this isn't necessary. Really."

"When Lenore and Diane met Harvey and Lev, didn't they come home and tell you? What's so different about how Noah and I met?"

"All right." She sighed deeply. "Tell me."

"Noah had some friends who never clued into him. At least, they never discussed it. They're also my friends. I've never been secretive about who I am. Once I moved away from Newfoundland, I vowed that I would not live my life as a lie. Anyway, one night they invited us both for dinner. No one will own up to whether it was planned or it was sheer happenstance. A couple of days after the dinner, Noah called me. I think he concocted some story to get my phone number from our friends. We went out for drinks and we realized immediately that we liked each other. Very much."

"He's a lot older than you."

"What does that have to do with anything? So a birth certificate makes him older. Big deal. I don't think either one of us has ever given a second thought to the age difference. Or, I'm sorry to say, the religious difference. I never really knew any Jews before I started going together with Noah. I went to a Catholic

school so I wouldn't have met any there. By the time I met Noah, I had ceased thinking of myself as Catholic. I hadn't stepped inside a confessional for a long time. Anyway, let me assure you that if you have problems with the religious differences, you're not alone. My mother's not too thrilled about it either. But the bottom line is that Noah and I don't see it as a stumbling block. It's not as if we won't know in which religion to raise the children."

The moment it came out, I knew I had made a serious gaffe. I had aimed for levity; it came out sounding like I was rubbing salt in her wounds.

"Your *pisk* speaks before your brain thinks."

"I'm sorry, I meant no harm. Really I didn't. I was making a joke. Obviously, it was in poor taste. Forgive me."

"Never ruin an apology with an excuse." She paused, and then spoke again. "I hear a lot about this illness," she said.

"AIDS," I said.

"Yes. Are you two careful? Do you use—protection? Forgive me, I'm repeating some words from a television commercial."

"Noah's an AIDS specialist. Don't you think he knows the score?"

"Doctors haven't died from this disease?"

"Everyone's died from AIDS. Rest assured, we practice safer sex. We're not promiscuous. We believe in the old values, too."

"And your health? You are both well?"

"Yes, Mrs. Wolfson, Noah and I are both well."

About twenty minutes later, I opened the door to Noah's room. He had left a small light on. As long as we had lived together, it was our custom to leave a light burning if either of us arrived home later than the other one. Was that some of Mrs. Wolfson's conditioning? Noah had never told me about any childhood fears. But I wondered if this was an old carry-over.

I undressed and crawled into bed. Noah adjusted to the movement in the bed.

"Did you survive?" he asked.

"I didn't mean to wake you."

"It's okay. I was trying to stay awake to ask how things went with my mother."

"Everything's fine, Noah. She gave me the third degree, which came as no surprise but I think we understand each other

better now. She really loves you and wants the best for you."

"You're the best for me so I hope she's come to accept that."

"It'll take awhile. I would like to think that her concerns for you and me are not unlike her concerns for Diane and Lenore. I think the hardest thing for her to accept is the failure for you to deliver an heir to carry on the Wolfson name. If she thought that there would be a grandson—"

"So she hasn't abandoned that yet. It's funny," Noah said, "that was always my concern, too. I hated the idea that the line ended with me."

"It doesn't end, Noah. What about Lenore's and Diane's kids?"

"It isn't the same."

"Noah, you mustn't let that get to you. I mean, I understand what you're saying. Here am I with six brothers, all straight, who will do their bit to keep our name alive. But unless you want to try adopting a child, I think you've got to find a way to accept the way things are."

"I know. I know. Still. ..." There was a sad resignation in his voice. "Patrick, make love to me."

"I thought—"

"I need to feel your body... another living human. ..."

He rolled over to face me. I could see tears beginning to well up in his eyes.

"Oh, Noah," I said.

"I'm sorry."

"You miss him, don't you?"

"I don't know what I'm feeling. All I know is, I want you to make love to me."

"Your mother's in the next room."

"She's a sound sleeper."

I understood what he wanted. And why. For the last couple of days, his life had been suffused with death. There is nothing life-affirming about a funeral, despite the rabbi talking about Mr. Wolfson's legacy to his family, especially to his grandchildren. The *shiva* was somber, as the appearance of each new arrival began anew the process of reliving memories and of tears again. Everyone talked about Noah's father as if he were still alive, in the kitchen perhaps getting a glass of tea. I couldn't understand the value of it

all, without the benefit of getting drunk like at a wake. Remaining sober, while everyone grappled with words to say that appeared positive, encouraging and uplifting, couldn't have been easy. It was an enervating experience for everybody.

I kissed Noah. I kissed away the tears. They left a salty taste on my tongue. Noah's skin always tasted slightly salty, like the prevailing salt spray back home. Especially the small of his back. When we made love, and we both worked up a sweat, there was always more moisture in the hollow of his back than anywhere else.

He pushed back the blankets and inched his body beneath mine. He'd told me at the very beginning that my weight on him was a secure, protective feeling, and I must never fear that I was crushing him. I began kissing his neck and tugging at his ear lobes. I kissed his shoulder blades and kept moving down his body, across his hairy chest. I knew where this was meant to lead, but the image of two censuring women, Mrs. Wolfson and Lenore, spitting through two fingers to ward off the evil in their midst, was far too funny and was keeping me from getting hard. I didn't want to let Noah down. I wanted to help him as best I could to rid the presence of death from his old bedroom.

"I don't know… " I began lamely. "Can't I give you a back rub, or something?"

"It'll be all right," he said. "I've never wanted you as much as I want you now." I felt his hand reach down and grab my cock. Noah then pushed back the foreskin and began rubbing the tip until it became slightly wet with cum. I remembered the first time we had sex, and how I had to teach him that exciting an uncut cock was a lot different than trying to arouse a circumsized one. In time he became quite adept at learning how to turn me on. If I groaned aloud now, I thought, as Noah stuck his finger into my ass, I could just imagine the looks Mrs. Wolfson would give me in the morning. "Patrick, fuck me. Fuck me hard," he whispered. I was convinced he was screaming it at the top of his lungs. "I want your cock in me. I want to feel it in me good and hard so I know that I am alive."

"Oh, Noah, I love you so much."

I awoke with a start. What was I doing having dreams about Robbie Bishop? I hadn't thought of him for years. Robbie Bishop,

the first boy I ever had impure thoughts about. Little did I know that he was thinking the same thing about me. One afternoon as we were walking home from school, we ducked into an alleyway and our dirty thoughts transgressed into blissful, albeit circumspect, actions. We continued having sex as often as we could until he moved to Halifax to take a job. I never stopped thinking of him as my closest friend. I got a letter about Robbie from my mother long after I'd settled in Montreal and become a librarian. Seems he'd gotten married and was moving home again with his new bride. So the first boy I'd ever sucked off had turned out straight and couldn't make the break from the island or the church. The power of Catholicism had reached out and lured poor Robbie back again. To what? There was almost no work in Newfoundland. He would wind up on the dole with half a dozen screaming children. At least one of us had escaped that destiny.

Beyond the window shades I could see bright daylight. I looked over at the alarm clock. Noah must have forgotten to set it when he turned in last night.

"Noah, get up. It's after seven. Noah. Come one. Get up."

"What's the matter?"

"Aren't you going to services this morning? Don't you have to say *kiddush*?"

"Oh Christ. I'm up, I'm up."

Suddenly, there was a knock on the bedroom door. "Are you awake, Noah?"

"Yes, Ma. I'm getting dressed. Shit," he said, turning to me, "I don't have time to shower. If I were Orthodox, that would be perfect. They don't shave or shower during the *shiva*."

"I never thought of you with a beard before. I kind of like the idea."

"People will stop us and ask for cough drops. Can you find me some clean underwear?" he asked as he scurried around the room. "Oh, by the way, I think you said I had to go to the synagogue for *kiddush*. That's the prayer over wine. I have to say *Kaddish*. That's the mourner's prayer. A slight difference."

"Hey, what do I know? I'm a goy from The Rock."

"You knew what it took last night."

"So I'm a talented goy."

"And I love you very much."

"I wonder if you'll still love me when I tell you what I did last night before I came to bed."

"Do I want to know?"

"I invited your mother to our place."

"You what?"

"Why not? Maybe if she sees how we live, and meets some of our more sedate friends, she won't feel so threatened, so out of the loop about us."

"Sounds to me like she's right there in the middle of the loop, Patrick."

"She didn't give me an answer yet, but I invited her for July."

"Pride Day's in July."

"That's when I'd like her to come. Maybe she'll march under the banner of Parents and Friends of Lesbians and Gays."

"You have flipped out."

I had purposely neglected reporting on my little run-in with Lenore last night. There would be time for all that when we got home.

"You'll never have her on your side if you hide it all from her."

"But Pride Day. Give me a break. Even I have some trouble with that scene."

"That's because at heart you're still in the cupboard."

"I am not."

When Noah had first asked me to move into his house, I sensed it was a difficult decision for him since I was the first lover he'd ever had. My decision was not an easy one either, because I didn't feel that Noah was entirely comfortable in his own skin and setting up a home for the two of us might prove too awkward. He was conflicted about being Jewish and being gay, a combination as damning as my being born a Catholic and living as an openly gay man. There had been women, he had told me, but when sex with them was over, he felt something was still missing. He was never sure what it was until one night he went home with a guy from a bar in the gay village on Ste. Catherine Street. That wasn't his first encounter with a man, but it was the first time he allowed himself to enjoy it and not just lie there while someone gave him a blow job. Yet once he'd come, his first thought was how quickly could he escape. Any idle chatter from that point on was almost too

painful for him. By the time we began having sex regularly until the time I officially became his companion, my greatest impact on his life was making him feel more at ease with intimacy. He eventually let me touch him in public, something he'd always frowned upon and tried, early in our relationship, to discourage.

"You're afraid she's liable to like all those gorgeous men. Or worse, you're afraid she'll see you drooling over them."

"This is payback time for my insisting you come home with me without clearing it with you first. That's what it is." He was knotting a dark tie. "We'd have to cancel our annual party."

"Here. Let me tie it for you."

"I'm a mess."

"So you're not ashamed of me but you are ashamed of our friends?"

"If this happens, it's on your head. I will not be responsible for the fall-out."

"We'll talk about it when we get home."

"You've really gone too far this time."

"Have you got your little bag with those black boxes and your prayer shawl?"

"Yes, I have my *tefillin* and *tallit*. I hope there's someone there to show me how to put these on. I haven't looked at them since I was thirteen. My mother kept them after I moved out."

"Good luck."

It seemed an odd send-off, wishing him luck. In a way I was providing approbation, telling him that I thought it was a good thing he was doing, attending services, standing up before his congregation with the leather straps of his *tefillin* binding him closer to his Judaism. When you said *Kaddish* in front of the rest of the congregation you showed what a good son you were, you paid your respect to your dead parent.

I suddenly felt something wash over me. What if Noah turned into Ben? Could I deal with it? Could he deal with it? If Noah decided to go the full eleven months of saying *Kaddish*, then he would have to believe that I thought it was the right decision. For both of us. I would even join him at the synagogue on Saturday mornings if he felt comfortable about having me beside him.

I looked out the bedroom window and saw him getting into his mother's car. He pulled out of the driveway and turned right

towards the synagogue.

We'll take it one step at a time. For the moment, I thought, he has enough on his plate. He has to learn the proper way of putting on his *tefillin* and praying in Hebrew again.

A FINE POINT

Allen Ellenzweig

Nearly all of my adult life I ate *treyf*: chestnut-colored Latino boys who delivered the groceries when I was home with the flu; slim-hipped Asian "adjuncts" who noted me watching them at our university gym; married strawberry-blond WASPs from Cheever country who wanted a quickie before heading home to Connecticut while I just happened to be cruising Grand Central Station at rush hour. Of course my friends claimed that I was interested in anything that was *ethnic* or that spoke a foreign language. By *ethnic* my friends meant anyone who was not, like me, Jewish, but rather bore the exotic stamp of some other immigrant group: Puerto Rican, Chinese, Korean, Brazilian, even newly-arrived Irish. For a foreign language, my friends said almost any strange tongue would do. This, they claimed, accounted for my WASP fascination: English spoken through the affliction of lockjaw and emotional deprivation.

What my friends didn't say outright, although they hinted, was that I was particularly fascinated with non-kosher meat, on the theory that they thought I thought that the *goyim* of every class and nationality are all uncut deli delights. They thought I coveted that extra flap of skin that sheaths the weighty prick of every Ivy League athlete, pharmacy delivery boy, financial arbitrager, and Harlem basketballer, Gentiles all. They never admitted, and I never reminded them, that in this day and age circumcision is widely practiced even among non-Jews. That would have spoiled the joke. Well, I could take the ragging and the innuendo. I encouraged this myth about my special taste for pork sausage and bangers. To play along, I repeated their favorite gay edict: "There are two things I can't stand: size queens... and small cocks."

Personally, I think it best not to inquire too deeply into why we go for the men we go for. It is true that the rapid staccato pitch of street Spanish—or any dialect of Chinese, Thai, or Korean—was

known to set my pulse slightly racing. And there was something especially exciting about having whispered endearments and obscene commands put to me in an unintelligible but musical froth of consonants and vowels. It started when I was younger, when my approaches were shy and often caught the *goyim* in question with a mixture of delight and suspicion. It was amazing to me how many young men not born to these shores, and decidedly not in the gay camp, or Camp, would let their third limb be sucked off by a native white boy.

Older, I let these young men make the first move under the mistaken impression that I invited their interest when what I invited was their curiosity. And of those well-suited investment bankers and Madison Avenue ad-men whom I delayed on their way to catch the five-forty to New Canaan, I can only say that my slightly Slavic Ashkenazi features seemed always to beckon them with the promise of fulfilling their secret wish to violate an intellectual Jew-boy. I have learned the rituals of country-club chatter and golf course lingo in many a midtown hotel room while a man pumped up from his lunch hour at the New York Athletic Club fucked me proper, then rushed off to buy his daughter a gift for her Sweet Sixteen, or his son a new bike at FAO Schwarz.

So no one could have been more surprised than me when I became smitten by a *landsman* at the progressive synagogue I attend on the High Holy Days. He was olive-complexioned—a good start—and built solid, always an incentive. He had small dark eyes and a noble forehead capped with short, lightly curling dark hair that was just beginning to recede. The nose was prominent and almost Roman.

I watched him over the course of one year's *Rosh Hashanah* and *Yom Kippur* sevices. He was ushering people to their seats while wearing an Armani knock-off. He seemed a pleasant fellow with a manner half-reserved and half-charming, a good boy who might have studied the Old Testament at Sunday school until he discovered that he was more interested in the story of David and Jonathan than was strictly required. He gave older women his arm and a respectful smile as he led them to a seat. He chatted up the dykes with tykes. He handed the older men their prayer books and talises. He bussed the cheeks of the gay male couples noticeable in our congregation; he knew them all. And then, brushing past him

on my way out of *Kol Nidre* services, I overheard him in an aside to a fellow usher.

"*Ah, mais celui-là est vachement con!*" he exclaimed *sotto voce*. My heart vaulted, then raced. A Frenchman. Ooh la-la!

Sensing my excitement, my friend Seymour turned to me and said, "He may *parlez-vous*, but down where it counts, he probably only has a dangling participle."

All the same, I began going to Friday night services. The Frenchman was a house regular. I watched his broad shoulders sway under his large woven tallis. His little knit *yarmulke* sat at the crown of his head without the aid of a clip or bobby pin. It was like magic: it never fell off even when he swayed while *davening*. I always found a seat that allowed him in my view. If ever he looked my way I nearly swooned. What a *punim*!

Later, at the kiddish, I watched him mingling with the male couples, a regular gadfly, or, in this case, a Godfly. The *fagellas* in the congregation were a beehive of dish and gossip. You could tell this by watching them commenting on other members of the congregation who passed. Yet he, a person of some position in the *shul*, was accorded both their affection and respect—and lustful gazes. I guess we all imagined him without his clothes: a hefty pair of shoulders atop a long, lean trunk, with dark nipples and a dark prick hanging down from beneath a rich burning bush. He would be the cause of several breakups, for sure, or maybe the occasion for that experiment *à trois* that some of the gay-marrieds had been dreaming of over their last decade and a half together.

But a few weeks of these Friday night *shabbos* observances persuaded me that I wasn't meant for the religious life. The fact was he was the only reason I was there, and although the young and hip rabbi who spoke on behalf of national health care and Arab-Israeli detente may have been the dream catch of a "red diaper" baby like myself, I finally had to admit that my French Jew was the only reason I was briefly feigning an observant life of Talmud and Torah.

Months passed during which I returned to my usual ecumenicalism. I dated a Venezuelan tennis player I met at New York Health & Racquet whose taut body quivered under my roaming hands. I tricked with a Polish emigré who cruised me on the street and asked if I had a sister willing to marry him for the

sake of obtaining his citizenship. A young Afghani cab driver picked me up in his taxi after my late night carousing at a gay bar; he quickly determined my interest, parked in a deserted warehouse district on the fringes of my neighborhood, and promptly asked me to "do him" before he went on his merry way. Oh, the shame. Delicious.

I had certainly forgotten my nameless French *landsman* by the time I boarded a flight to the southwest, final destination Santa Fe where my aging ex-Communist parents run a health-food store cheek-by-jowl next to a shop selling Native American jewelry. My parents, by the way, grew up singing the *Internationale* on the Lower East Side of Manhattan, went to City College where they met, raised money for the Spanish Loyalists, and stayed in the party until the Soviets invaded Hungary. God, but they are exemplars of their type. What they never did, despite themselves having Ortho-dox parents, is ever set foot in a synagogue the whole of their adult lives. In rebellion, I have decided to defy them on this point—and many others. Still, it explains my years of summer camp near Poughkeepsie with other "red diaper" babies where we learned to sing along with The Weavers and later, on his own, with Pete Seeger. For my part, I scandalized everyone by tricking my way through the Paul Robeson bunk.

Anyway, there I was ready to take my trip to Santa Fe via Albuquerque when, on line ahead of me with his boarding pass stuck in his mouth, I sighted my *landsman* from *shul*. There was no edging closer to him what with my awkward luggage and the formalities of airport etiquette, but I kept my eye trained on his passage down the rabbit hole leading to the smiling stewardess greeting us aboard. What luck! He and I were moving down the same aisle inside the plane. He was entering a row a few ahead of mine, forcing me to brush past him. My groin and thighs grazed his firm buttocks pressed inside tight faded jeans. He was looking nothing like the good Yeshiva boy all dressed up for his prayers. He was, if anything, looking all dressed down for mine.

Midway through the flight he walked up the aisle toward the head. I tried to catch his eye, but no dice. I had a sudden urge to take a pee and follow him. Which I did. We wound up waiting in the same small crowded space outside the rest-station, while stewardesses scurried to and fro and toddlers crawling underfoot

made themselves cute for the passengers. Of a sudden he turned toward me, gave me that look which is the unmistakable acknowledgment of one friend of Dorothy to another, then casually turned aside again.

"Are you French?" I asked boldly.

He turned to give me a queer sort of look.

"No. Canadian. Why do you ask?"

"You probably don't recognize... I also go to Temple Shirley Temple."

He smiled politely, then took in what I said and began to giggle, then cracked up. "I'd never heard that before!"

"That's what some of us call it. Anyway, I recognized you. The only time I ever heard you talk, you were speaking French. So you're French Canadian?"

"No, actually, though I'm from Montreal. But I always hung out with the French-speaking kids. My parents—they're refugees. They survived in France during the war—we're from Poland— then they lived in Paris where I was born, then moved to Montreal when I was six. I don't know. What does that make me? Anyway, I speak *Quebeçois* French refined by a year's study in Montpellier."

He paused, as if realizing he'd gotten himself into a considerable moment of self-revelation with a total stranger. Then he looked over at me a little slyly and said, "I'm *Emmanuel*, Manny, Potasinzki. What's your name?" He'd pronounced Emmanuel in the French. I thought I'd cream my pants.

"Rueben. Cohen. Pretty boring, huh?"

"Well... I don't know. Depends, don't you think?"

Suddenly, one of the little toilet doors creaked open and a corpulent burgher in a leisure suit stepped past us with a guilty look, as if to suggest he hadn't washed up the sink properly, or perhaps he'd left a stink. Manny turned quickly and spoke.

"You can go ahead if you'd like."

"What's the matter? Scared he didn't leave a scent of pansy at twenty-five thousand feet?"

He laughed.

"No... it's just... where you staying?"

"My parents' place. Santa Fe. For a week. Why don't I give you their number?"

"Uh... great."

"You go ahead. I'll write it out on a card and be here when you get out. Go on. Just hold your nose and breath through your mouth."

I scrambled back to my seat, pulled out from my carry-on a business card from the university's Office of Public Affairs (wouldn't you know?), and wrote my parents' telephone number on the back. I waited near the rest station again and suffered the stares of those behind me on the queue who couldn't credit why I urged them forward as each stall emptied. But when Manny emerged from his, I simply stuffed the card down the rear pocket of his jeans, enjoying the surprise on his face and the shock of the woman waiting on the other aisle, and said, "Don't forget to call. Otherwise, I'll tell everyone at Temple Shirley Temple you're a heartless bastard."

I did not have to wait long, for by the second day of my stay I was rediscovering cliff-dwelling ruins and Edward Curtis photographs beside my princely *boychik*, ten years my junior but with a vast knowledge of the sufferings of Native Americans. Although I was becoming acquainted with his store of knowledge about the Southwest and various Native American cultures, he otherwise mastered great emotional reserve. He would say something flirty and then withdraw—as though afraid he'd gone too far. He blushed when I made a *double-entendre*, but he could talk at length about archaic, fierce Indian rituals, or the gender-bending of the *berdache,* or the architecture of the Pueblo.

Finally, toward the end of my stay, we sat face-to-face dining intimately on swordfish mesquite and blue corn enchilladas. I had grown silent staring into the dark pools of his button eyes. I had by then grown oblivious to the charms of doe-eyed local boys with long black braids and turquoise jewelry who passed us on the streets of Santa Fe or sat nearby in truckstops and diners on our highway stops to Taos. Now, across from Emmanuel, I realized that it had been so long since I had fallen in love; I was surprised to find myself overcome with timidity.

"We should fuck with each other back in New York," he said, suddenly breaking the calm.

"What a nice idea," I agreed.

He had yet another week left: of touring in and around Santa Fe, then on to visit friends in San Francisco. Back in my own New

York apartment, I fretted the length of those seven days, imagining that he would of course engage in the very sexual wanderlust for which I'd become famous among my friends. In Santa Fe, he would find some ruddy mestizo laborer to console his lonely nights, and in San Francisco a bodybuilder into leather would introduce him into crudely played out scenes of domination and submission.

My anxiety had reached near fever-pitch by the time of his return, but when I opened the door to receive him the evening after he came back, he simply fell into my arms and planted a long and satisfying kiss upon my lips, burrowing his tongue into my mouth like a critter digging in for winter. We explored each other first with clothes on, peeling away the layers like miners seeking a hidden lode. He dug his hands down the rear of my slacks, and I down his, there to feel his skin all smooth and warm. We helped each other out of our T-shirts; I marveled at the beautiful stretch and tension of his torso, the tips of his nipples pointing out as I leaned in to suckle. His strong hands kneaded my neck while I rubbed his small but solid biceps. And then he rose so I could slide his black jeans to the floor and uncover his hidden root that I felt slowly firming under pressure: his flat belly with its tightly wound nib gave way to a nest of dark curly hairs that imitated the aureole of his handsome head. And as I slid his pants further down, wondering when to close in upon him, his penis bounced out from the prison of cotton briefs and hung half-staff. I drew back in wonder and confusion. I put my fingers to it to confirm the evidence; I played the extra membrane back and forth, assured it was so. Emmanuel was not circumcised.

We made love as two men do. Robust and tender. We played back and forth like bear cubs testing strength and stamina, pinching tits till we nearly pierced the air with cries, and kissing hard then soft, our evening stubble rubbing our faces raw and red. His tongue ravished places normally covered by day. We climbed aboard each other and with pharmaceutical precautions engaged our engines to the task. *Oooooop-la!*, as the French say.

"*Que c'est bon!*" he moaned. "*Encore, encore!*" That's so good. More, more.

And so it went, riding each other, stallions on the mount. It hurt, then not, as all dissolved into the pleasure of being pried open

and explored with repeated thrusts and parries.

Exhausted with sweat, we lay in each other's arms and fell asleep, content in our peaceable kingdom. Hours later, in a morning still dark, we awoke and stroked each other gently, our fingers grazing one another like the wind threshing wheat. I remembered then what I meant to ask, but for fear of offense had let pass.

"Manny?"

"Yes..."

"How come... I mean... how come you're not... ?"

The very air stood still.

"How come... I'm not *circumcised?*"

"Well... not to put too fine a point on it... yes."

"Does it bother you?"

"No... just curious. I've certainly met up with the condition before." I neglected to add *just not with Jewish men.*

I thought I could hear him thinking in the stillness. Again the calm of early morning reigned. I turned to watch his face staring up at the ceiling as if for some divine inspiration. I leaned into him, hugged his body to me, planted a kiss upon his shoulder.

"It must have been the bane of my father's youth," he began, speaking slowly and slightly hoarse. "Even before the Nazis. When he was a kid the local boys would taunt the little *kikes,* pull down their pants and beat them up. By the time he was a teenager in hiding, it meant life or death. He tells the story of a group of *milice*—this is France now—rounding up a whole village of men and having them strip. If a man was circumcised, he got hauled off, unless he could show a baptismal certificate on the spot. If my father had ever been denounced, or found in his hiding place, he would have been *kaput.* So later, long after the war, he wouldn't let me be circumcised. No matter what my mother said. It was an offense to God, she said. My father said 'Then it's on my head, not the boy's. I'm making my own covenant with God.' And so, in Catholic France where I was born, my parents never looked for a *moyel. Fin.* But for *his* disobedience to God, my father had me properly educated in Jewish lore and tradition. We were very observant in Montreal. Now, I still observe the Sabbath. Hey, it's the least I can do."

"You are active in the synagogue, aren't you?"

"I head up the gay and lesbian group. I help out on major

holidays."

Suddenly, Manny let out a little laugh.

"I have thought about getting... circumcised. But I'm not much into the idea at my age. Anyway, it makes for a conversation piece... with some men."

This was the start of our romance. My friends were quickly impressed. Manny, said Seymour, was a "catch." They were planning our nuptials within minutes of meeting him. He was a *mensch*, they agreed, and ex-lovers outside the faith and companions on all sides urged us forward with intimate dinner parties and theater tickets, museum outings and country weekends, courtside quarterfinals at the U.S. Open and opera tickets at the Met.

"So ante up," said Seymour on one of our rare outings alone in the weeks since Manny entered the picture. "What other endowments does he have?"

I paused, then I hesitated. I knew what kudos I could garner with the anatomical details. Seymour would broadcast these within minutes of our parting.

"In that respect," I answered poker-faced, "Manny's quite normal."

This was already five years ago, and I have told no one otherwise since. It is certainly not a topic for conversation with the *kiddish yentas* after *shabbos* service where I go with Manny religiously, so to speak. And in our secular life, Manny and I change together at the gym, Manny facing into his locker; he is at all times discrete about his body's display. I stand close in as if to protect a secret. I husband him to me... and keep them guessing.

Afterword: Diaspora, Sweet Diaspora

Lawrence Schimel

The other day, my sister remarked that I was looking "less gay." What she meant was that I looked more masculine—thereby exposing her own (well, society's) prejudices about effeminacy and the often-widespread notion of gays being "less than men." I have, in fact, never looked more gay: I have a close-cropped buzz cut, a goatee, and the results of a year's worth of working out in a gym. In fact, the only thing I'm missing to be a perfect '90s clone is a tattoo, something tribal perhaps, on my left or right arm.

But I'm a Jew, and Jews don't do tattoos.

While I don't practice Judaism, I was raised a Jew, and that cultural heritage is hard to shuck off. A tattoo would preclude my being buried in a Jewish cemetery, and while this issue of where I'll be buried is something that I hope will remain a long way in the future, being buried with my family in the Jewish cemetery where I already have a plot is something that I'm not sure I want to give up. I may change my mind someday, renouncing the restrictions of the cultural identity I was born into (Jew) in favor of one I have chosen (fag), but until then I'm heeding, or at least not challenging, Jewish custom and law.

My being a Jew is more or less an inescapable, irrefutable fact because I was born to a Jewish mother, the most widely accepted criteria for Jewish identity. Even were I to convert my religion, many people—Jews and non-Jews alike—would still consider me to be racially or ethnically a Jew.

Because my being gay was not apparent or known—to myself or anyone else—until later in life, my homosexuality is seen to fall in a spectrum of identities, because there was a time when I (like all children) was heterosexual-by-default. Queers are born assimilated,

we're raised to be heterosexuals, and only later in life do we separate ourselves from straights—not so much to defy their homophobia as to help us find each other.

Being gay was for a long time thought or said to be "just a phase"—odious and pejorative rhetoric, to be sure, but one that I prefer to the notion of genetic causality now in vogue. My discomfort with this new position stems from its inherent presupposition that, if one had a choice, one would obviously not choose to be gay. Being "born gay," we're guiltless for our sexuality—which, admittedly, may have been a useful response to the repressive psychiatric notions that homosexuality could or should be "cured," but one which gets my dander up. Given my anxieties about disease, about passion and love, my decisions to have sex are quite conscious.

I may have been born a homosexual, with a biological inclination or preference toward sexual activity with members of my own gender (assuming, for the sake of this argument, a rigid bipolar gender system with no blurring or reassignment or other gray area), but I *choose* to be gay. I signify this physically by adopting the muscle-clone look so prevalent here in Chelsea, New York City, where I live, and in much of the gay media, even if I don't practice all the rituals (drinking, drugging, smoking, partying) of the clone lifestyle. I am not simply someone who happens to have sex with other men; I am choosing to live a gay lifestyle, in a gay ghetto, and writing largely (though not exclusively) on gay concerns. I have willfully adopted and constructed an identity based on my sexuality (easy enough to do as a post-Stonewall baby, given the freedoms, liberties, and rights won by queers who lived and fought since before I was born) and therefore resent this notion that I was born to be queer. (It's a good thing I'm not Protestant, since I'd have the same problem with predestiny vs. free will!)

The idea of being "born gay" presupposes a rigidly bipolar sexuality, Kinsey zero heterosexuals and Kinsey six lesbians and gay men, which I know, from my own experience and those of the people in my life, to be far from the case. Gay sex and sexuality transcend racial, religious, class, and other identities—we recognize a unique kinship across all these various divides. And in fact we often romanticize these differences, eroticizing, for instance, working class men as the most masculine and therefore "least gay."

A Jewish identity also supersedes class (and to an infinitesimal degree racial) difference, for a Jew is a Jew regardless of other aspects of his or her background. But when it comes to sex, we do not always look to other Jews—although it is assumed by our families that when it is time to settle down and raise our own family we will choose a Jewish partner. What is taboo or "other" often becomes eroticized through our fascination with it—as an American Jew, I am fascinated (if sometimes also unnerved) by the foreskin I lack. "*Shiksas* are for practice," goes a joke among Jewish men, using the pejorative Yiddish term for non-Jewish women, who are OK to fuck but not to marry.

My mother is happiest if I'm dating a Jewish man rather than a non-Jew, even if she'd prefer I found a woman to marry (and she'd settle for a *shiksa*!). She also fits to a "T" the cultural Jewish mother stereotype of wanting me to find a doctor or a lawyer, and there was a time when I stopped being the black sheep of the family by bringing home a nice Jewish boy with a profession—real estate—at a time when my sister was dating an Irish Catholic. While my upper-middle-class family would prefer that my sister marry a well-to-do Jewish man, they'd prefer a poor Jew over a wealthy Latino or African-American. There is another Jewish joke, "*Tsuris* is a Yiddish word that means your child is marrying a non-Jew." (*Tsuris* is Yiddish for "intense aggravation.")

What the Jewish community fears, of course, in these intermarriages and relationships, is assimilation. We define ourselves by our otherness, our separation and difference from the goyim, those who are non-Jews. In my experience, nowhere is our Jewish difference more apparent than in an interfaith relationship; my Jewish friends in mixed-faith relationships have a far stronger sense of their identities as Jews and an awareness of Jewish culture and tradition than the Jewish couples I know.

We hold onto our Jewish difference so as not to disappear, even while we may crave a kind of "invisibility" where our Jewishness is merely another aspect of our personalities—the way I am a writer or my mother a teacher. Jews would continue to be Jews even in the absence of anti-semitism, whereas I'm not sure that there would be a need to be gay if the homosexual act were ignored instead of vilified. The existence or possibility of a similar gay invisibility, in contrast, is a myth in our current culture, since

being closeted or passing is not some mythical haven but a cessation of identity and existence. When I have sex with another man—regardless of his race, class, or religion—the very act of our congress is the fundament on which our gay difference and community is based. There is no gay equivalent to inter-faith assimilation, merely denial.

I have a very public gay persona, particularly since I've written about sex I've had with other men, and often write generally (such as now) about gay sex and sexuality. Many of my books are specifically intended for a gay audience (even if occasional others read them). This presupposes the existence of such an audience, and my being a part of this cultural group.

When I say I'm a gay man, what I mean (and what everyone automatically assumes) is that I like to have sex with men, primarily if not exclusively. That's all. Being gay is presupposed to be a performative identity—that is, my identity is based on or reinforced by this act of desire, if not the sexual acts themselves.

My identity as a bourgeois American Jew is much less performative. Ostensibly I am meant to go to temple and pray, to observe Jewish custom and laws. The fact that I do none of these things provides no hindrance to my self-identity as a Jew—I have a secular identity as a Jew, completely divorced from the practice of Judaism.

Is it possible for me have an identity as a gay man, similarly divorced from the homosexual acts that are the literal process of being gay? Certainly I consider myself gay even if I have not actually had sex with another man in whatever quantity of time one wishes to choose. There is no statute of limitations, or requalification criteria, that I must have sex with a man every set period of time or renounce my identity as a practicing homosexual (though as a young red-blooded American male, I try not to let it be too long between these identity-affirming episodes). Likewise, before I had sex with anyone, I recognized my desires for other men, even as I tried to deny their existence.

But what about me is gay, aside from these desires, whether they're acted on or ignored? I don't deny that I live my day-to-day life in a gay environment, but I am hard pressed to determine what is authentically gay about it.

West Coast thinking would have me believe there is a gay

spirit or sensibility which infuses everything in my gay life. Is it because I'm a born New Yorker that I resist this thinking, or is it in much the same way that I bridle at the notion of genetic causality for my sexual identity?

We have a gay culture: art, literature, media by gays and about the gay experience.

We have created gay communities, our semi-mythical mini-Zions: San Francisco's Castro, New York City's Greenwich Village and Chelsea, Provincetown, Fire Island's Pines and Cherry Grove, West Hollywood, Key West, Amsterdam, sectors of Berlin and London. (There are lesbian Zions as well: Northhampton, Park Slope, Palm Springs, etc.) These are our cultural homelands, and our visits feel like a return home, even if we've never set foot there before.

I like living in a gay ghetto. I take reassurance from it. I like walking down the street and cruising and being cruised, even if I'm not interested in whoever's cruising me or if the boy I've got my eye on ignores me. There's something about that moment of shared recognition of sexuality which builds community. I feel erased sometimes when I travel and heterosexuals don't even recognize that I'm cruising them—I feel I don't even exist.

I can feel this same sense of recognition when I meet Jews, although it is usually less visually oriented. There is a shared history, cultural references, identity, and, although I find it lacking in the energy that gay cruising has, that outpouring of affability and desire and interest.

While I feel a bond of recognition when I meet fellow Jews, I also feel a twinge of embarrassment when I see Orthodox Jews, whose lives and lifestyles are so radically different from my own bourgeois Jewish identity. Where I live in Chelsea, I come into contact with the Chassidim daily, since the half dozen photo shops on my block are all run exclusively by Orthodox Jews who live in Orthodox communities out in Brooklyn and Queens and arrive by the busload each morning and depart the same way each afternoon. Their extremism is so distant from my comfortable secular Jewish existence, I resent being lumped in with them by non-Jews.

I think the Orthodox embarrass me in much the same way that assimilationist queers get upset by the outlandish openly-sexual modes of dress of the drag queens and leather fags in the

Pride Parades. While the drag queens and leather fags are equally distant from the normative gay lifestyle I lead, I am unperturbed by their display and spectacle—I am in fact actively in favor of their inclusion in queer events—largely because my political and politicized identity as a gay man is one of my choosing.

I am a Jew by accident of birth, however, and am not ashamed of this discomfort the Chassidim cause me. While I identify strongly as a Jew, I am a post-Zionist American Jew who has also distanced himself from the practice of Judaism, which these Orthodox Jews so strongly represent with their distinctive, hirsute visual appearances.

When I talk about Post-Zionism, I am primarily talking about a change in Israel-diaspora relationships, though the term also applies to a school of thought that challenges Zionist thinking and is sometimes used to designate changes within Israeli society. I am a diaspora Jew, meaning I am descended from the tribes that have scattered across the globe and have not made *aliyah*, have not returned to the homeland of Israel. I have no desire to make *aliyah*; I plan to stay right where I am.

I was taught to pray in our common Hebrew language, though I was not taught the language itself. I do not understand the words I am praying, and I strongly resent this ignorance, the fact that I have these blessings and prayers hardwired into my memory with no idea what they mean. This linguistic alienation is only one aspect of my disaffection with Judaism, though it reinforces my Post-Zionist identity as a Jew disinterested in Israel as the sole focus of my Jewishness.

As the political climate in Israel in relation to the Middle East changes and evolves, especially with the ongoing Peace Process, it becomes harder for American Jewry in general to maintain Israel as the vicarious anchor of Jewish identity—if, in fact, it ever was. Zionism's primary goals were to create a Jewish territorial, demographic, and political presence, accomplished with the founding of the State of Israel in 1948, and to achieve recognition and acceptance of this State of Israel from its Arab neighbors. One of the major tenets of Zionism is the Law of Return, which stipulates that any Jew anywhere can immigrate to Israel and claim immediate Israeli citizenship. Historically, this option has held little appeal for American Jews; according to Hanoch Marmari writing in *The*

Jerusalem Report on February 8, 1996, only 98,000 American and Canadian Jews (an average of 2,100 each year) have made *aliyah*— less than four percent of the Jews immigrating to Israel from around the world.

As I was growing up, before the fall of the Iron Curtain, American Jewry mobilized to help Soviet Jews flee religious persecution and claim this safety offered by the Law of Return. (At my temple, we children went door-to-door among our neighbors selling macaroons and chocolates to raise money for Soviet Jewry.) A representative survey of American Jews conducted in 1990, the National Jewish Population Survey, shows that one-third of American Jews report making a contribution to these established institutions during the year prior to the survey, and American Jews continue to funnel money to Israel via these organizations.

My general feeling is that these contributions happen to a lesser degree lately, which may simply be my distance from my Sunday School years when I was regularly attending temple and being exposed to this information. Perhaps it is because my peers, immediately post-graduation, can't afford to contribute money anywhere no matter how deserving the cause. But I think it is primarily due to the fact that the State of Israel recently celebrated its 50th anniversary, and there is less apparent need for such contributions—politically and economically Israel has become more independent than during my childhood.

Zionist thinking has often assumed that this philanthropy toward Israel provided a backbone for Jewish identity among diaspora Jews. My feeling is that the reverse is true: those Jews for whom their sense of identity as a Jew is important to them, those Jews who received a Jewish education and take part in and feel part of a Jewish culture and community, feel an imperative to support the State of Israel and its mission to protect and provide refuge for threatened Jews. I think the rest of us need some sort of threat to remind us to contribute; we don't feel Jewish because we contribute, but because we feel Jewish (and identify with the perils of being Jewish in a non-Jewish world) we contribute.

This element of peril is a galvanizing force toward community, as witnessed with the AIDS pandemic and its effect on gay culture. Before HIV was properly identified, the disease was referred to as GRID (Gay Related Immuno Deficiency) because

it was first discovered among gay men and was considered to be "only" a gay disease, beginning the seemingly-inextricable linkage of gay identity and AIDS. ACT UP, Queer Nation, and other activist groups of gay men and lesbians coalesced because of AIDS and challenged the homophobic heterosexual culture to pay attention to this disease, to fund research toward a cure, and to treat those living with and suffering from the disease with the compassion and humane treatment they deserved. These groups came to represent a queer identity to the media, and united lesbians and gay men, politically and socially, across our often-separatist homosocial circles. Queers put aside their difference to fight our common enemy (in much the same way the religious right will put aside their differences to fight *their* common enemy: us). In many ways activism and a shared sense of outrage and frustration became the building blocks of our gay communities, as we fought for our lives and the lives of our lovers and friends.

More than a decade into the crisis, identity as an openly queer individual presupposes a political support of funding for AIDS research, even if it no longer presupposes approval or support of AIDS-related activist groups such as ACT UP. For a long time, diaspora Jews in America have felt that their Jewishness needed to inform their political views toward Israel, and especially Israel-diaspora politics, but this, too, is changing. We live in an era where an Israeli Jew has killed a beloved Israeli Prime Minister, Yitzhak Rabin. How are we to feel now, besides outrage and frustration? Why does death seem necessary to effect change, be it political or social? It took the Holocaust to cause the founding of a Jewish nation-state, thereby introducing Jewish concerns to the Western-centric stage of world history, and it has taken the ongoing devastation wreaked by AIDS to put queer visibility on the map of world events and politics. The cost, in both cases, has been too dear.

The persecution of queers continues from the heterosexual culture's intolerance if not outright hatred of our very existence. So much of our gay community and identity is formed in a reaction against this oppression rather than stemming from an integral authentic need or experience. I resent that the heterosexual culture manipulates our actions so strongly in this way, from our Pride Parades defying their homophobia-shame to our need

for full-time watchdog organizations like Lambda Legal Defense and GLAAD, the Gay and Lesbian Alliance Against Defamation (paralleling the Jewish Anti-Defamation League).

In today's culture, a gay identity is perforce a necessary stage toward true sexual liberation, the freedom from all identity politics, the freedom *not* to need to define and justify our sexualities and sexual choices.

The Israel-diaspora relationships that comprised Zionist thought were likewise a necessary stage of religious liberation and protection for Jews; even within Zionist rhetoric, however, this was only a stage. An important part of the foundation of the Jewish nation-state is its independence from other countries (insofar as any country can be independent in today's global political community). Zionism-as-philanthropy is but one aspect of Jewish identity for American Jews, and it is largely dependent on the preexistence of a strong Jewish identity.

We post-Zionist Jews have begun to separate what is Zionist from what is universally Jewish, and one of the major Zionist tenets being overthrown is *shelilat hagolah*, the negation of the diaspora, the idea that all Jews will either make *aliyah* or cease to identify as Jews. In today's complex political climate, an assumed allegiance to Israel is no longer such a strong part of our Jewish identities; while still remaining globally aware, we American Jews construct our Jewish identities closer to home and embrace our diaspora identity.

Gays are beginning to embrace our diaspora as well, choosing to stay home and come out wherever we are rather than moving to our mini-Zions of gay culture. And many of us in these Zions are choosing to leave, to form smaller enclaves outside of these arenas, to live queer lives in suburbia or rural sectors. We are learning to embrace our other cultural identities and still feel gay. The major factor driving most gays to our gay Zions is isolation and the need for community, but now it is possible not to be the only openly-gay man in Small Town, USA, and it is more and more possible to interact with gay culture through mass media— magazines, films, the internet—from anywhere in the world. Sure, it's fun to visit these cities, but they're no longer as essential to being gay as they once were.

Non-urban gay life seems inconceivable to so many of us, but

I feel that way as a Jew, too. (I am, after all, a Jewish intellectual living in New York, so tradition and history suggests that I should stick around.) But for today's gay Post-Zionist Jew, nothing is written in stone any longer, not the Ten Commandments of my Jewish forefathers nor the gay myth of Stonewall as the primogenitor of gay liberation.

Even remaining in one of the mini-Zions of both gay and Jewish life, the spectrum of my identity and opinions is constantly changing and evolving. By the time this essay is published, I may have shifted my position on either (or both) my gay or Jewish identities. Who knows, ten years from now, I may be leading a suburban Republican lifestyle, with a wife, 2.4 kids, a dog, a mortgage, and a picket fence.

Chances are likelier, though, that I'll have a tattoo, something tribal perhaps, on my left or right arm.

AUTHOR BIOGRAPHIES

Allen Ellenzweig is the author of *The Homoerotic Photograph: Male Images from Durieu/Delacroix* (Columbia University Press). His art and photography criticism and commentary have been published in periodicals including *Art In America, American Photographer, The Village Voice, Out/Look: National Lesbian & Gay Quarterly, Times Literary Supplement, Response: A Jewish Student Quarterly*, and the *Harvard Gay & Lesbian Review*. His first published short story appears in *Men on Men 7;* this is his second. He lives in New York City.

Daniel M. Jaffe is the editor of *With Signs and Wonders: An International Anthology of Jewish Fabulist Fiction* (Invisible Cities Press). His translation of *Here Comes the Messiah!* by Dina Rubina, a Russian-Israeli novel is forthcoming from Zephyr Press. His short stories and essays have appeared in *The Greensboro Review, The Chattahoochee Review, Green Mountains Review, The James White Review, Response: A Contemporary Jewish Review, Jewish Currents,* and *Soviet Jewish Affairs* (UK). He is the recipient of a Massachusetts Cultural Council Professional Development Grant, holds an MFA in Writing from Vermont College, and teaches fiction-writing at UCLA Extension (online) and The Cambridge Center for Adult Education.

Michael Lassell is the author of a collection of short stories, *Certain Ecstasies* (Painted Leaf Press); three volumes of poetry: *A Flame for the Touch That Matters* (Painted Leaf Press), *Decade Dance* (Alyson; winner of a Lambda Literary Award), and *Poems for Lost and Un-lost Boys* (Amelia); and a collection of essays, stories, and poems titled *The Hard Way* (Masquerade). He is the editor of five anthologies: *Men Seeking Men* (Painted Leaf Press), *The Name of Love* (St. Martin's Press), *Eros in Boystown* (Crown), *Two Hearts Desire: Gay Couples on Their Love* (with Lawrence Schimel; St. Martin's Press), and most recently, *The World In Us: Lesbian And Gay Poetry Of The Next Wave* (with Elena Georgiou; St. Martin's Press). He is the author of *Elton John And Tim Rice's Aida: The Making Of A Broadway Show* (Disney Editions, 2000). A former editor of *L.A. Style* and *Interview* magazines, he is the articles editor for *Metropolitan Home* magazine. He lives in New York City.

David May is the author of *Madrugada: A Cycle of Erotic Fictions* (BadBoy). His fiction and non-fiction have appeared in *The Harvard Gay & Lesbian Review, Advocate Men, Cat Fancy, Drummer, Frontiers, Honcho, Inches, International Leatherman, Lambda Book Report,* and *Mach.* His work also appears in the anthologies *Bar Stories, Midsummer Night's Dreams: One Story, Many Tales, Cherished Blood, Flesh and the Word 3, Meltdown!, Queer View Mirror,* and *Rogues of San Francisco.* He studied dramatic literature, specializing in medieval religious theatre, at the University of California at Santa Cruz. He lives in San Francisco with his husband, a dog and two cats.

David O'Steinberg's work has been published in *The San Francisco Bay Guardian, The Evergreen Review,* and *The Chiron Review,* and in the anthology *A Loving Testimony: Remembering Loved Ones Lost to AIDS,* among other publications. He lives in San Francisco and can be reached at ostein@dnai.com.

Andrew Ramer is the co-author of the international bestseller *Ask Your Angels* (Ballentine Books) and the author of the Lamda Literary Award finalist *Two Flutes Playing: A Spiritual Journeybook for Gay Men* (Alamo Square Press). He lives in the San Francisco Bay Area.

Rick Sanford is the author of the posthumously published novel *The Boys Across The Street* (Faber & Faber), from which "Isaac and Moshe" is excerpted. Rick Sanford performed as a gay porn star during the 1970s under the name Ben Barker. His short fiction can be found in the anthologies *Men on Men 2* and *His 3.* He passed away in 1995.

Brian Stein, a graduate from the Radio and Television Arts Course in Toronto, has primarily written radio copy and other media-related text. He has also written restaurant and book reviews for the *Toronto Star* and other papers. His first published short story appears in the anthology *Quickies 2* (Arsenal Pulp Press Ltd.); this is his second. He works as a full-time travel agent, and is currently single. "Thanks to James and Jon for friendship and editing skills."

Jonathan Wald, in addition to writing, also directs theater and film. His first short film, *Just Out of Reach*, has been screened at over 20 festivals worldwide and will premiere on Dreamworks/Imagine's website Pop.com in May 2000. Jonathan's second film, *In My Secrecy*, has played at a dozen international festivals and has received a Cine Eagle Award, second prize at the University of Oregon Queer Film Festival, and the Audience Award for Best Short at the Washington DC Lesbian and Gay Film Festival. His poetry has been published in *The Badboy Book of Erotic Poetry* and *Ells S'estimen: Poemes D'amor Entre Homes*. He is currently a graduate student at UCLA film school and recently received a Fulbright to study filmmaking in Australia.

About the Editor

Lawrence Schimel is a full-time author and anthologist who has published more than 40 books, including *The Drag Queen of Elfland* (Circlet), *The Mammoth Book of Gay Erotica* (Carroll & Graf), *Switch Hitters: Lesbians Write Gay Male Erotica and Gay Men Write Lesbian Erotica* (with Carol Queen; Cleis Press), *Two Hearts Desire: Gay Couples On Their Love* (with Michael Lassell; St. Martin's Press), and *Boy Meets Boy* (St. Martin's Press), among others. His anthology *PoMoSexuals: Challenging Assumptions About Gender and Sexuality* (with Carol Queen; Cleis Press) won a Lambda Literary Award in 1998. He has been a finalist for the Firecracker Alternative Book Award, the Small Press Book Award, the Spectrum Award, and the Lambda Literary Award. His work has been anthologized in over 150 collections, including *The Practice of Peace, XY Files, Best Gay Erotica 1997* and 1998, *The Random House Book of Science Fiction Stories, Gay Love Poetry, Nice Jewish Girls*, and *The Random House Treasury of Light Verse*. His writings have been published in Basque, Catalan, Czech, Dutch, Esperanto, Finnish, French, German, Italian, Japanese, Polish, Portuguese, Russian, Slovak, Spanish, and Swedish translations. His website is http://www.circlet.com/schimel.html. He currently lives in Madrid, Spain and New York City.

GLOSSARY

Yiddish is a combination of German, Hebrew, Aramaic, Polish and other languages. Transliterating the phrases into English creates many different spellings. These definitions are offered to enhance the enjoyment of the stories and should not be considered complete.

boychick—affectionate term for boy; can also be used in a sarcastic or critical way

daven / davening—ritual bending of the knees during prayer that causes the body to sway backward and forward

fagellas / faygelah—literally little bird, used in American-Jewish vernacular for homosexual

goyim—non-Jews

kaddish—prayer in Aramaic that praises God. Although it does not mention death it is used at the conclusion of a service as a mourner's prayer.

kibbutz—a type of agricultural commune in Israel

kiddush—literally sanctification. The prayer that sanctifies the sabbath and holy days. It is recited over wine.

kipah—another name for yarmulkah, the ceremonial head-covering worn by Jewish men to show respect for God when inside a temple, or in general for Orthodox Jews

landsman—fellow countryman

lomed vuvnick / lamed vavnik—the 36 ordinary people who are so pure of heart that God does not again destroy the world with flood or fire or so forth. Because no one knows who these 36 are, one is taught to be kind and offer hospitality to all people, in case they are one of the lomed vuvnick.

mamma loshn / mama-loshen—mother tongue or Yiddish

mezuzah—a small tube containing a scroll with the shema placed on the doorframe of all Jewish households to consecrate the house. Some say it is to commemorate the escape of the Jews from Egypt and the Angel of Death's passing over the homes of the Isrealites during the 10th plague.

mikvah—ritual bath

minyan—the minimum number of adult males (10) necessary to maintain a temple and for congregational prayers

Mishnah—part of the Talmud. The codified core of the oral law.

mohel / moel—man who circumcises the male baby on the eighth day in the ritual of brit milah

nachas / naches—special joy particularly in the achievements of one's children

pisk—literally mouth; slang for loudmouth

punim—face

shabbos / shabbat—the seventh day; from sundown Friday night to sundown Saturday

shalom—salutation meaning hello, goodbye, and peace

sheggitz / shaygets—non-Jewish male, male form of shiksa

sheyna—beautiful or handsome

shiksa/shiksas—derrogatory term for non-Jewish girl

shul—temple or synagogue

sidder—prayerbook

Talmud—massive compilation of debates, dialogs, commentaries, and commentaries on commentaries interpreting the Torah

tate—affectionate word for father like "papa" or "dad"

tallis / tallit—prayer shawl. A traditional Jew receives a tallis at his bar mitzvah from his father, from his bride at his wedding, and is buried wearing a tallis.

tefillin—phylacteries. Two thin staps with a square black box on it containing passages from Exodus and Deuteronomy. Wrapped on to the arm in a ritual prescribed way by traditional Jews during morning prayers.

Torah—literally doctrine or law. The five books of Moses or (in English) Genesis, Exodus, Leviticus, Numbers, Deuteronomy

treyf / trayf—any food that is not kosher

yarmulkah / yarmulke—see kippah

yente/yenta—gossipy woman, anyone unable to keep a secret

yiddishe punim—Jewish face

ABOUT THE PRESS

Sherman Asher Publishing is an independent literary press publishing fine poetry, memoir, fiction, Judaica, books on writing, and other books we love since 1994. We publish both regional and international voices that engage us and deserve a wider audience. We are dedicated to "Changing the World One Book at a Time."™ Visit our web site at www.shermanasher.com to order our titles.